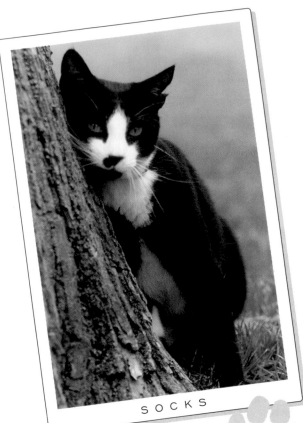

SOCKS

Dear Socks,

Kids' Letters to the First Pets

SIMON & SCHUSTER

Dear Buddy

BUDDY

Hillary Rodham Clinton

SIMON & SCHUSTER
Rockefeller Center
1230 Avenue of the Americas
New York, NY 10020

Copyright © 1998 by the National Park Foundation
Foreword copyright © 1998 by the National Park Foundation
All rights reserved, including the right of reproduction in whole or in part in any form.

Simon & Schuster and colophon are registered trademarks of Simon & Schuster Inc.

DESIGNED BY BARBARA MARKS

Manufactured in the United States of America

1 3 5 7 9 10 8 6 4 2

Library of Congress Cataloging-in-Publication Data is available.

ISBN 0-684-85778-2

To our nation's children,

whose curiosity, thoughtfulness,

and good humor

should inspire us all

To Socks and Buddy

(and all other pets)

who give their unconditional love

and companionship

to us humans

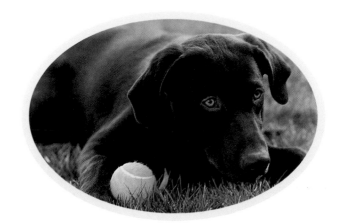

Contents

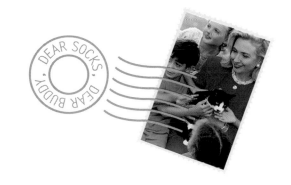

Foreword

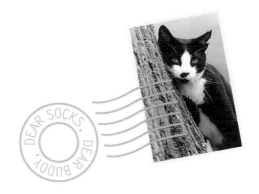

A few weeks after Bill, Chelsea, and I moved into the White House, letters and postcards from across the country began arriving, first by the bundle, and then by the bin. Waist-high stacks spilled out from offices into the hallways. Most of the letters were for the President, who at every campaign stop encouraged the American people to keep in touch and let him know what was on their minds. But a lot of the mail was for our black-and-white cat, Socks—a spontaneous outpouring of affection for the first feline to live in the White House since Amy Carter's Siamese, Misty Malarky Ying Yang.

Over the years, Socks has heard from animal lovers of all ages, including admirers from England, Bangladesh, and nearly 50 other countries, who have written asking for celebrity shots and "paw-tographs" (his paw print signature). And since our chocolate Labrador retriever, Buddy, bounded into our lives, he has acquired lots of pen pals of his own. Together, Socks and Buddy have received more than 300,000 letters and e-mails, as well as hundreds of handcrafted gifts (you will see several of them in the photographs included in this book). By comparison, Thomas Jefferson, one of the most prolific correspondents of his day, received an average of 137 letters a month while he was President. Who says the art of letter writing is dead?

One of my favorite stories about letter writing has to do with a predecessor of mine in the White House, Dolley Madison. And by coincidence, Mrs. Madison demonstrated what it means to be a devoted pet owner as well.

During the War of 1812, in the year 1814, President James Madison was out leading his troops against the advancement of the British forces. He sent word to his wife that the British had broken through the lines and were marching on to Washington and she had to flee. But instead of leaving when she was first ordered to do so, Mrs. Madison stayed behind to collect the most prized possessions in the house. The single

most important object, she felt, was the fabulous Gilbert Stuart portrait of George Washington that hangs in the East Room of the White House. While the frame was being broken and the picture removed, she hastily finished a letter to her sister in which she described being within the sound of a cannon. "And now, dear sister, I must leave this house . . ." she concluded. "When I shall again write you, or where I shall be tomorrow, I cannot tell!!"

I think of Dolley Madison not only taking the time to gather the painting, her husband's cabinet papers, and other historic treasures, but to write to her sister! Her letter is so important because it illuminates a part of our history. One of the last valuables that Mrs. Madison managed to carry out of the executive mansion was her colorful pet parrot. It was moved to safety just before the British set fire to the White House.

The letters to the First Pets were written under vastly different circumstances from Dolley Madison's letter to her sister, of course. But they document our time as Mrs. Madison's letter did hers.

Establishing a connection with the First Pets is often a child's earliest encounter with the White House, the office of the President, or even the workings of government. Children of previous generations

all the food you want?" "Do you have a Secret Service agent?" "Do you ever annoy the President?" "Are there any good mice in the White House?" "What do you do for a living?" The mail is so voluminous that our cat and dog cannot answer every question. We're fortunate that many of the retired servicemen and women who live at the U.S. Soldiers' and Airmen's Home in Washington, D.C., volunteered to pitch in, helping the animals send out greetings and photos. Each of them has a heroic, untold story. Many of the veterans served their country in World War II, Korea, or Vietnam. I would like to thank all of them, especially William Woods,

wrote to F.D.R.'s dog Fala or the Kennedys' dog, Pushinka. To celebrate today's young citizen-writers, I'd like to share some of their letters to Socks and Buddy and help them get to know our cat and dog better.

Children often ask Socks and Buddy: "How does it feel to have

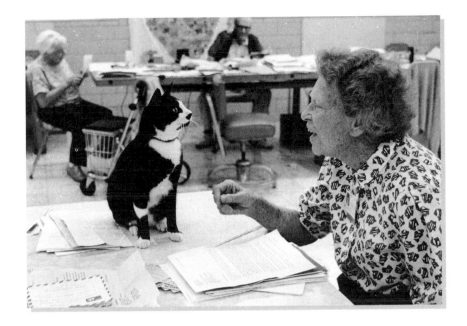

Allan Gordon, Norman Godfrey, and Layne Whitman, for graciously taking on a new self-appointed tour of duty opening, sorting, and answering the letters.

Long before we got to the White House, Bill and I realized the importance of trying to reply to everyone who writes us—even those who send notes to our pets. When Chelsea was just five years old, she decided on her own that she wanted to write a letter to an elected official about an issue that concerned her. She was adamant, and so we sat down with her and talked about it and helped her with some of the spelling. She sent it off and every day she waited for a response. I still remember the

disappointment I shared with her when one never came.

We don't want anyone who writes to the White House, especially a child who signs his message "Your Friend," to feel that it is just a one-way street. Back-and-forth communication helps youngsters understand that writing serves a real purpose in our everyday lives. Even more important, when a letter is reciprocated, it makes people feel that they've been heard and that they matter.

Writing a letter is also a wonderful way to express oneself. Letters are one of the most powerful forms of writing because they are so personal. I've been gratified by the pleasure that

so many people have taken in Socks and Buddy, and at how imaginative their letters often are. Children and their animal friends have extended many invitations to our cat and dog to fetch sticks, chase squirrels, or simply to get away from the White House for what they perceive as some much-needed R & R. And Socks has received his share of marriage proposals. (I suspect that most people think Buddy is still too young for anything more than puppy love.)

Pictures are a frequent gift from pen pals. Socks and Buddy have a large collection of portraits of their feline and canine friends. Some children embellish their letters with wonderful drawings, stickers, or paw

prints. One fifth-grade class imagined all of the activities in which Socks might participate and then sketched them—Socks in pajamas, Socks jogging with the President, Socks taking a catnap on Chelsea's bed. And when Buddy moved in, another group of students had a contest to see who could design the best newsmagazine cover announcing his arrival.

Encouraging girls and boys to write letters also helps them to learn that these gestures of kindness count. Soon after Buddy joined our family, Socks was deluged with messages from children who wanted to console him about having to share the White House with another pet—a *dog,* no less. "Maybe you need to teach that dog some cat manners," a young letter writer suggested. Others offered support to Buddy. "I got used to my brother," wrote one child, "so I'm sure you will get used to Socks."

What touches me most about the letters is how much the children give of themselves. Besides their desire to learn more about the animals, they want to let Socks and Buddy know who

they are, too—describing other members of their families, what they like to do best on their birthdays, what their favorite food is (pizza ranks high on the list). Some of the questions they ask reflect what's going on in their own lives, like "Do you get in trouble sometimes?" or "Have you ever broken a window?" Buddy and Socks hear from many children who can't have a dog or cat of their own because of family circumstances—they live in a small apartment or their parents or siblings have allergies. Writing to our pets can be a good way for them to express their disappointment or to articulate the complex emotions of growing up.

As every writer knows, making the transition from concept to written word can be difficult. It's often useful to have a sounding board to help clarify one's thoughts or polish a turn of phrase. I could not have had a more perceptive associate than Linda Kulman, a more insightful editor than Sydny Miner, or a more talented designer than Barbara Marks.

Assembling these letters from children to Socks and Buddy gives me the opportunity to share with you some of the many laughs and loving moments that Bill, Chelsea, and I have enjoyed with our pets. Of course, our cat and dog are much too busy greeting visitors, sitting in on Oval Office meetings, and catching up on sleep to do an "as told to" memoir. Instead, I've

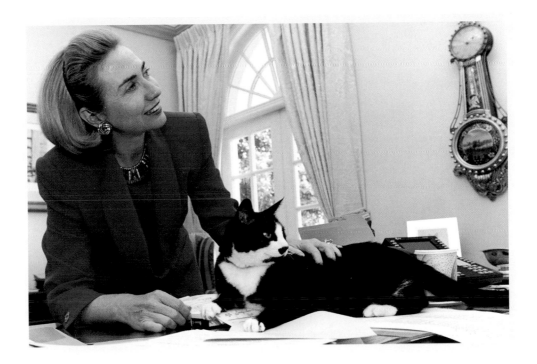

decided to tell you my favorite stories about our pets and show you some pictures from Socks and Buddy's personal photo album. I'd like to thank everyone in the White House who helps care for and play with the First Pets, and in particular my thanks to the White House photographers whose archival photographs fill these pages, especially Barbara Kinney.

I hope you have as much fun reading *Dear Socks, Dear Buddy* as I have had putting the book together.

Hillary Rodham Clinton

To. Dear Socks,
What is it like to live in the
White House. Do you miss
Chelsea? Does she like Stanford
Do you make Presiesident
Clinton sneeze. Where Do you
sleep.? Love morgan

Dear Buddy,

 Do you ran away alot because if you do, you might get lost, or worst, you might get hit by a car. My dog almost got hit by a train once.

 My dog chews my homework. I hope you don't chew the President's papers, or else!!!

 Your friend,

Sam Gardner

Dear Socks,

Meow! Meow! You are pretty.
My name is Kayla. Are you a
boy or a girl? Is it fun to be
the presidents cat? I hear you're
having puppy trouble. But I like
cats better than dogs. I have two
cats and a dog. My cats were crazy
but now they are calm

Your friend,
Kayla Tlach

Dear Buddy,

Hi! My name is Jordan Fleischman. I have two brothers and two sisters. My hair is sandy color and my eyes are blue. I maid it to the Spelling B. What kind of dog are you? Are you keeping Chelsea busy? It was nice talking to you.

Your friend,
Jordan Fleischman

P.S. Please send me a picture of Buddy.

Dear Socks,

Have you separated your socks? What do you do all day?
Can I have your autograph please and Bill's? I will put a piece
of paper in for your autograph. OKay? I need a picture of Bill
and you. The stuff I like in school is math, lunch, music, gym
and trips. We went to a show and it was fun. We ate lunch
before we went and we went on a bus. We watch TV in school.

My friends are Paula, Danielle, Anna, Meg, Leslie,
Michelle, Kayla B., Kayla K., and my teacher Mrs. Kovac.

Love,

Aimee Buchanan

P.s. Please write back

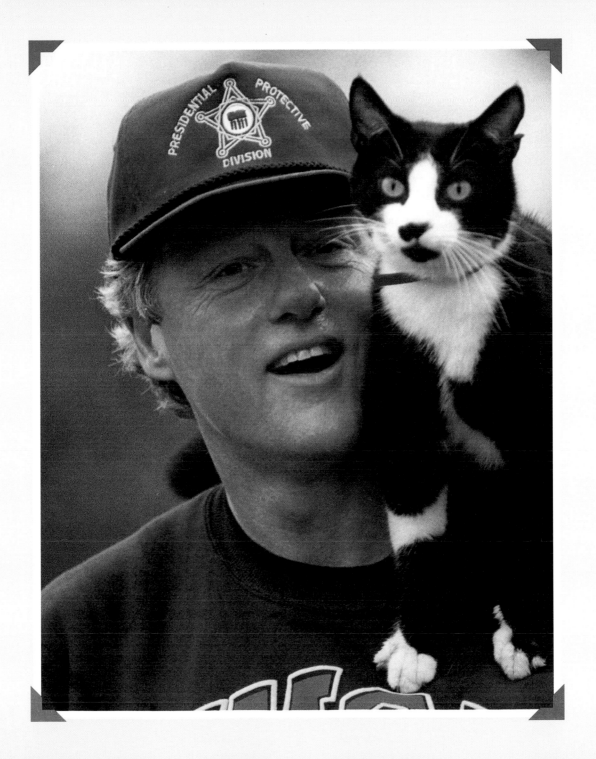

Dear Socks,

My name is Amanda
Robbins I am in third
Grade. I'm $8^1/_2$. My
birthday is April 5, 1989.
I adore cats. I think they
are cute

What is it like to be
the 1st cat? I love your
nice fur. How does it feel
to have Buddy in your
family? Do you have royal

cat food? Is their secret

service men and secret

service cats to watch you?

You are the most coolist

cat ever to walk the erth.

Ples right back and ples

come to my house. I Have

Fish At My House.

Sincerely,

Amanda Robbins

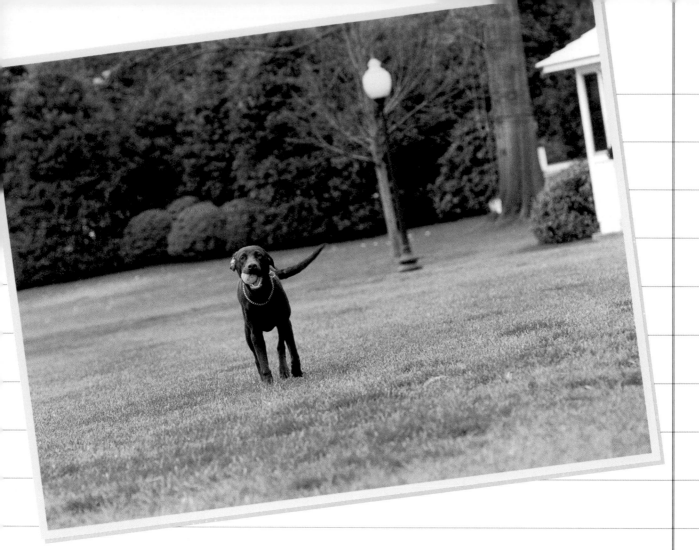

Dear buddy how are you doing in the white house? Is Bill taking care of you? Do you like tennis balls? Are you being nice to Socks?

We have a golden retriever named Samantha. She is a hound. She loves to eat. Her favorite foods are Bagels and toast. When she was about 3 1/2, Sammy went down the slide at the playground! When we have friends sleeping over, Sam gets very etcited, and tries to steal some of their clothing—especially Socks! Would you Please send us a picture of buddy? thanks a lot.

Your friend Ben

and his mom

Dear Socks,

 Hi my name is Kyle. I go to school at Belvidere Elementry in Belvidere N.J. My school is very big and long too.

 Some of my hobbies are hockey, basketball, and kickball, and some other things too. What are some of your favorite hobbies?

 I also like to play golf just like my dad. My dad is very good at golf. That is why he goes to golf courses all over.

 I have six family members in my house. They are my mom, dad, sister, my dog, my cat, and me. I hope you have just as good a family as I do.

 Sincerely,

 Kyle Britton

P.S. Can you please send me a photo of you please?

Dear Buddy,

I heard that you are the new dog in the White House. Do you get along with socks? I heard that you are a black labrador. You probably look like my neighbor's dog. Are you still a puppy or a full grown puppy? Oh, by the way my name is: Amanda Sbei and I am in Arrowhead Elementary School. Do you get good doggy bones? I have a dog and her name is Ginger. She is a collie. Who watches you when your owner's gone? On Feb. 26, 1998 my dog had to go to the vet because she dislocated her toe. I hope that you never dislocate you toes!! Do you love to snuggle up with your

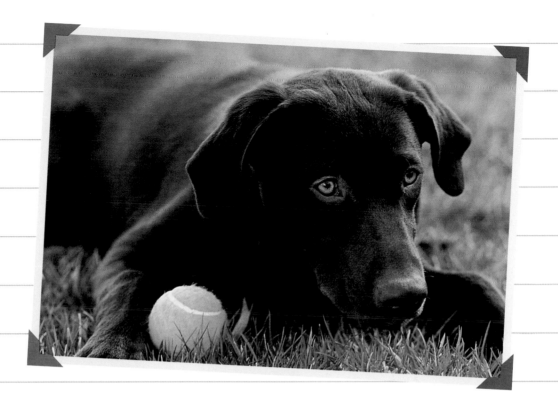

owners? How big are you now? How long have you been in

the White House. I hope you are happy living there!!

Sincerely,

Amanda Sbei

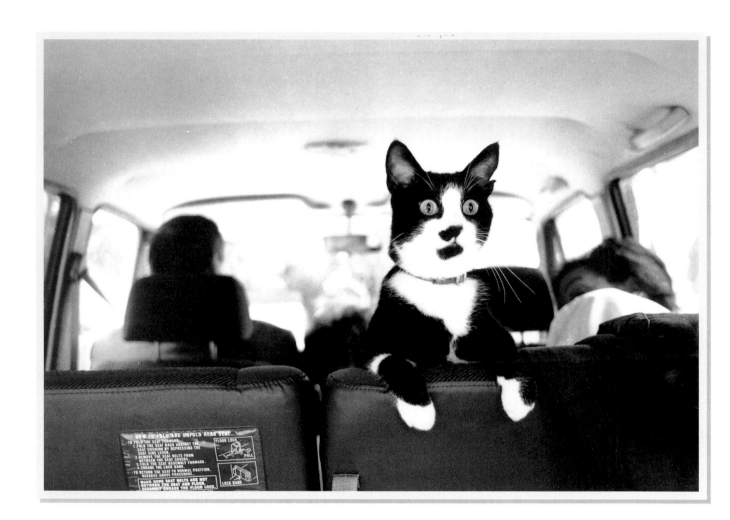

Dear Socks,

My class and I just finished reading a book about you. D Can you please send me a picture and a paw print. Do you any fleas? I think my cat has fleas.

When I grow up I want go to the Navy to be a pilot, or a football player.

Sincerely,
Kevin Torres.

Dear Socks & buddy
I hope that you are
friends. Socks hope
you don't like fish
cause I have some.
I live in Hilton Head,
S.C. Mayby you all
would like to come
here! Love, Taylor

P.S. Can I get
a picture of you all
please.

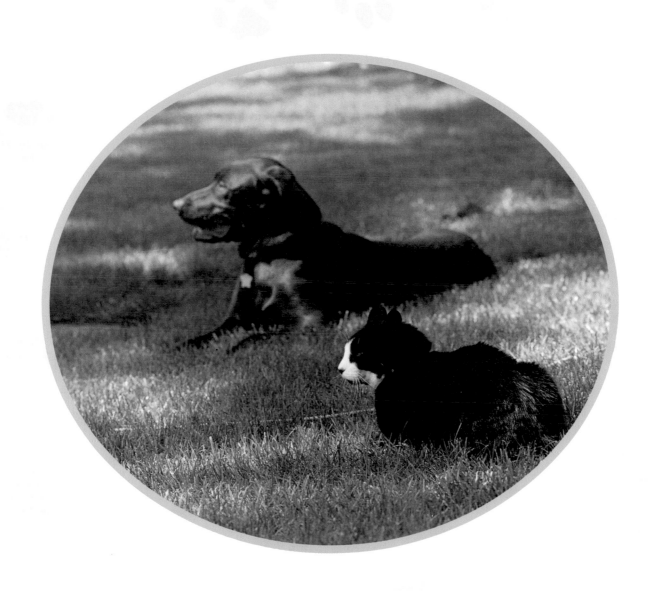

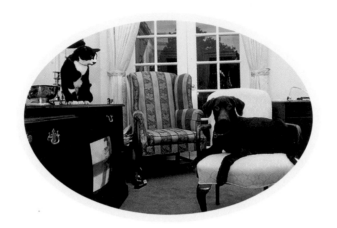

Paw Prints in the White House

The White House became home to our family on Inauguration Day—January 20, 1993. But Socks didn't want anything to do with unpacking. He preferred to arrive after his bed and litter box already had been put in place, pulling up to 1600 Pennsylvania Avenue on Super Bowl Sunday after a two-day car trip from Little Rock. Socks is only the fourth cat to live here since Franklin Roosevelt took office in 1933, so he became something of an international celebrity. He has been immortalized in poems, commemorated on postage stamps in a foreign country, and has even become a well-

known figure on the Internet, where his cartoon persona takes children on cybertours of the White House.

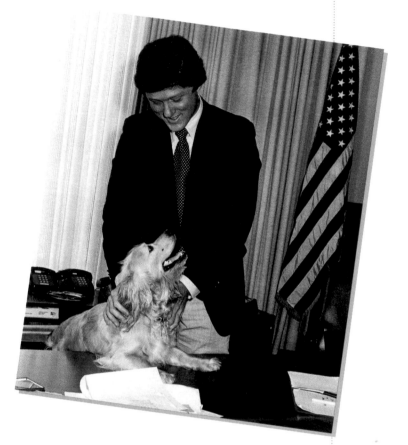

When Buddy joined us in December 1997, the four-month-old puppy was just as taken with Socks as everyone else. But the feeling was not mutual. I get the sense that a chocolate Labrador retriever is not the little brother Socks always wanted. It took only one meet-and-greet, however, for the puppy and the President to become inseparable.

But for both Bill and me, Socks and Buddy had a hard act to follow. Our first pet was an intrepid butterscotch-colored cocker spaniel named Zeke that I gave to my husband before Chelsea was born. From the time he was a puppy, Zeke was full of dogged resolution. No fence, no gate, no leash could keep him penned in. He'd bite or dig his way through or around any barrier. Sadly, his wandering ways finally caught up with him one fall day in

1990, when he dashed into the street and was hit by a car. We buried him in a stand of pine trees on the grounds of the Governor's Mansion in Little Rock and put a bronze plaque there to remember him. Losing Zeke was tough on all of us.

After he died, we didn't want to get another dog right away because we felt so sad. But one day the following spring when I took Chelsea to her piano lesson, we spotted two kittens rollicking in her teacher's front yard. Although the teacher had been making

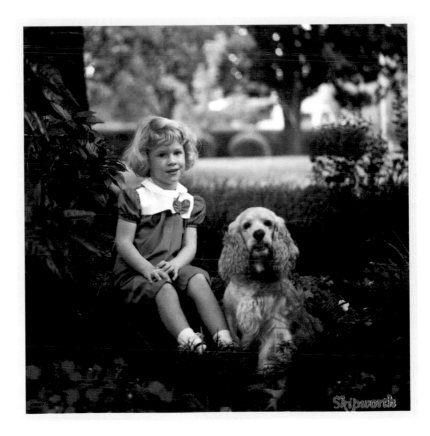

calls for several days to try to reunite the small strays with their mom, she hadn't had any luck and didn't know who else to phone. As we were walking to the car, Chelsea reached out to the kittens and the black one with white paws—Socks—jumped right up into her arms. That clinched our decision to make him part of our family. We also arranged a good home for Socks' sibling, Midnight, with the help of a local animal shelter.

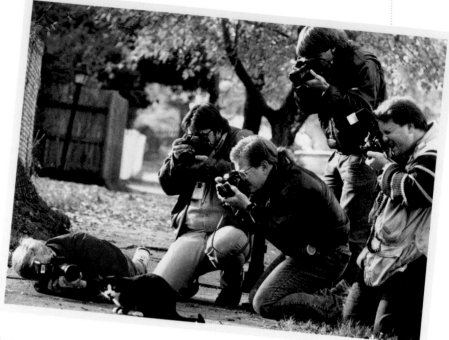

When we still lived at the Governor's Mansion, Socks proved himself to be a great explorer. He'd have adventures and then return with his head held high. But when he became

"First Cat–elect," as the press dubbed him after the 1992 election, he had to adjust quickly to becoming a public figure. One November day, when he strolled unsuspectingly out of the yard to go on his usual rounds, a pack of photographers coaxed him into their viewfinders with some catnip and snapped a picture that landed him in

all the papers—so much for leaving home without a disguise.

Although the Secret Service protects the White House and its inhabitants, Socks and Buddy don't have their own cat and dog agents. And at more than eighteen acres, the White House grounds are too big for a cat to roam around by himself. Because he could easily slip through the iron fence into the traffic and crowds, he prowls the South Lawn on a long leash. We worried that Socks might not like the restriction. But it's the advice we got, and it has kept him safe. The lead hasn't stopped him from monitoring the comings and goings of squirrels and birds in his territory, or even from making feline friends. For a few months, a stray tabby cat we called "Slippers" visited Socks and shared his water and food.

Socks loves to spend sunny days in the yard behind the Oval Office, where the President's secretary (one of our cat's greatest fans) can keep an eye on him. He has shown impeccable taste in his choice of shade trees. His favorite is a beautiful, historic pin oak planted by President Dwight Eisenhower and his wife, Mamie—one of the forty-one commemorative trees that Presidents and First Ladies have planted on the White House grounds. (Socks has been on hand to help Bill and me plant several trees, too.) During the summer, when Washington turns notoriously hot and sticky, our

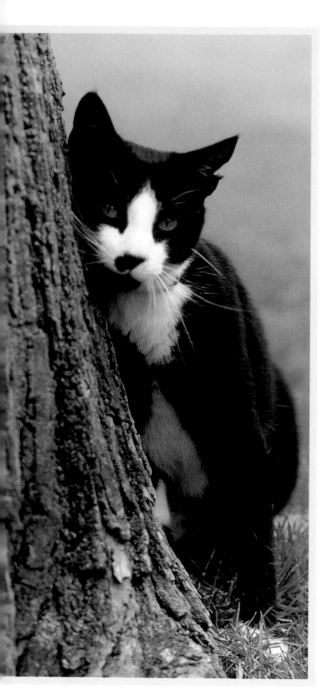

resourceful cat usually abandons his regular post to take refuge in the thick hedge by the backyard swimming pool built for President Gerald Ford.

While he doesn't have free rein inside the White House, Socks has found some spots especially cozy. At naptime, he often snuggles on a wing chair in the receiving room just outside the Oval Office in the West Wing.

Once, while Socks was perched on the President's secretary's desk, he came upon his own double—a ceramic cat with the same distinctive black and white markings. Socks' instinctive reaction was to pounce on the intruder (one of the many like-

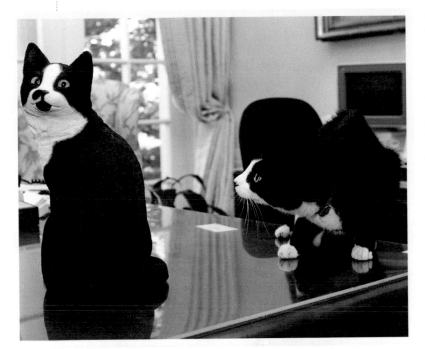

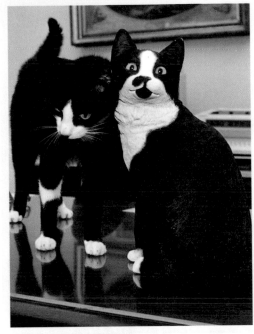

nesses he's received from fans during his tenure as First Cat), no matter how handsome. He arched his back, his hair went up, and he batted it with his paws. It was only when the look-alike didn't make any effort to fight back that Socks figured out what was going on. Quickly recovering his feline composure, he lightly brushed up against his new friend as if to say, "I guess we're in on this joke together."

When the weather gets too cold or rainy, the cat usually saunters over to the Visitors' Office in the East Wing. He's discovered that the high back of a Queen Anne chair there makes the perfect window seat for him

to keep tabs on what's going on outside. Sometimes, he jumps up on a staff assistant's desk to look over her paperwork or take a sip of water from a vase of flowers (which he once inadvertently sent crashing to the floor!). The Visitors' Office is home to a plush three-story "cathouse" complete with scratching post, a gift handcrafted by a devoted F.O.S.—Friend of Socks—in Florida. That's where Socks curls up when he really wants to get away from it all. Not even Buddy has discovered this hideout yet.

Before Buddy joined our family, we often talked about getting another dog. Finally, after Chelsea went off to college, we decided it was the right time. When we thought about what kind we'd like, a big dog seemed to make the most sense. We hoped that a larger breed would be easier to keep track of around the White House. We also had heard that Labs are particularly smart, loving, and playful. Born nearby in Maryland, Buddy arrived at the White House one afternoon for a tryout with the President. Within minutes, he convinced Bill that he was the perfect candidate for First Dog. They bonded so quickly that when they sat down on a bench in the backyard, it looked as if they were two friends catching up on old times.

Our first challenge was to pick the perfect name. We received hundreds of clever suggestions in the mail. A few of my favorites were

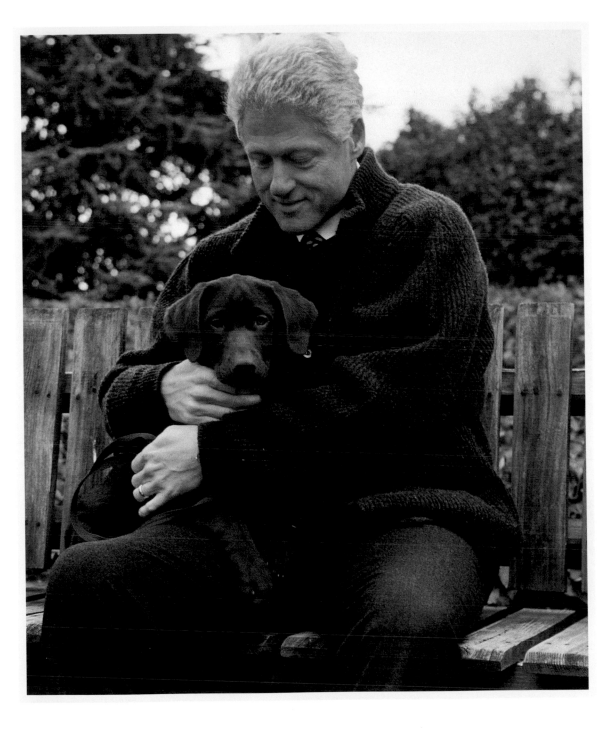

"Barkansas," "Arkanpaws," and "Clin Tin Tin." One little girl came up to me and offered "Top Secret." We had to laugh when we imagined the President running around the South Lawn calling "Top Secret, Top Secret." After much deliberation, we managed to narrow the list down to seven. We wanted Chelsea to have a say, so we waited for her to come home to meet the puppy. Finally, we settled on Buddy, the nickname of my husband's favorite uncle, Oren Grisham, who had passed away. Uncle Buddy raised and trained dogs for more than fifty years, and one of Bill's favorite childhood memories is going to his house to play with them. We think Uncle Buddy would have loved his namesake as much as we do.

Socks and Buddy follow in the paw prints of many distinguished pets at the White House. Until the early part of this century, it was not uncommon for the first families to keep farm animals on the South Lawn where our dog and cat play. President William Taft was the last to turn a cow out to pasture on the grounds to provide his family with milk and butter. Her name was Pauline Wayne. Other presidents

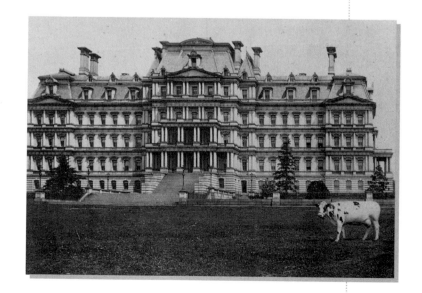

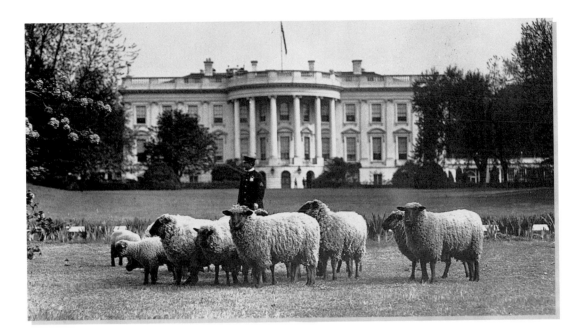

brought a favorite horse. To set a good example for all Americans during World War I, President Woodrow Wilson grazed sheep at the White House, including a ram known as Old Ike, so the gardeners could serve their country. What he probably didn't count on, though, was that the sheep would not just keep the grass trimmed but would snack on the shrubbery and flower beds. I believe they managed to redeem their reputations with President Wilson when their wool drew $100,000 at an auction held in 1918 to raise money for the American Red Cross.

Theodore Roosevelt's six children had a fantastic menagerie that included snakes, a one-legged rooster, a black bear, and two kangaroo rats.

Their best-known pet was an Icelandic calico pony named Algonquin. Once, when one of the boys, Archie, was in bed with the measles, two of his brothers, Quentin and Kermit, decided to cheer him up by sneaking the beloved pony up to the Residence on the elevator to say hello. I marvel at their inge-

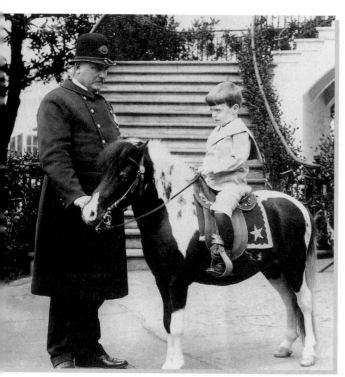

nuity. Whether or not the pony had anything to do with it, Archie did make a full recovery. Today, you can see the elevator, complete with a mannequin of a young boy and a papier-mâché brown pony inside, on display at the Smithsonian Institution's National Museum of American History in Washington. Some people even insist that the impression of Algonquin's hoof is still faintly visible on the floor.

Macaroni, another famous White House pony, belonged to Caroline Kennedy. Many Americans came to know Macaroni when a photo of him pulling the children in a sleigh around the White House grounds was featured on the Kennedys' family Christmas card in 1962. Caroline frequently rode

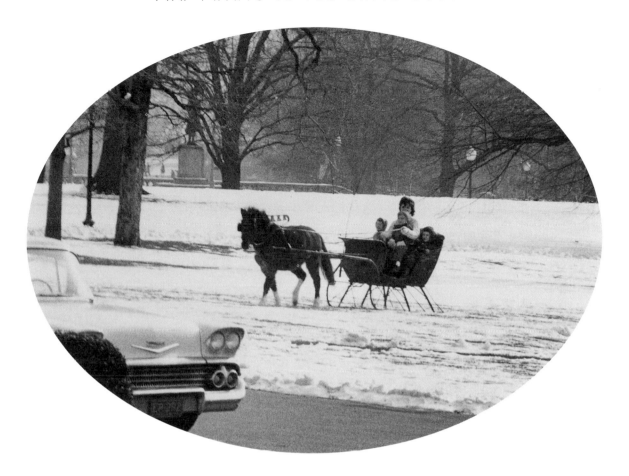

Macaroni on the South Lawn. One day while President Kennedy was at work in the Oval Office, he looked up and saw Macaroni staring back at him through the window. The President gallantly invited the pony inside. Mac-aroni, however, simply turned and strolled away.

One time, family and friends were gathered at the Kennedys' week-end house in Virginia when another of

Caroline's ponies, Leprechaun, pulled a memorable stunt. President Kennedy was sitting against the side of the house feeding the pony sugar cubes, and Leprechaun caught on to the source of the treat. As he tried to nose his way into the President's pocket for more, he nudged J.F.K. so forcefully that he knocked him over. Lying on the ground, the bemused President called out to his photographer, "Are you getting this, Captain? You're about to see a President being eaten by a horse."

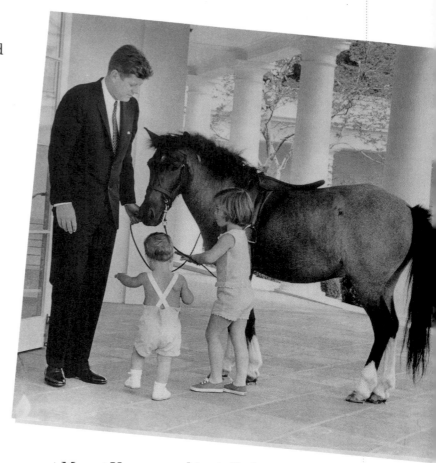

There were dozens of First Cats and Dogs who preceded Socks and Buddy, including some who had the honor even before there was a White House. Martha Washington kept cats at Mount Vernon and installed a special door for them. The Father of Our Country had his own pack of hunting dogs.

Teddy Roosevelt was a great cat and dog lover. One feline who

made a name for himself was his six-toed cat (his name was Slippers as well). He had a penchant for showing up on the grandest occasions. After one formal dinner, President Roosevelt was escorting the wife of an ambassador from the State Dining Room to the East Room when he came upon Slippers stretched out in the middle of the hallway. Rather than move the cat and hold up the line, the President simply led the woman on his arm around the purring obstacle, forcing the line of ambassadors and ministers behind him to follow suit.

The cat who belonged to President Rutherford Hayes was the first Siamese kitten ever brought into this country. Besides Socks, the modern presidency boasts only three other cats. Amy Carter's Misty Malarky Ying Yang, Susan Ford's Siamese, Chan, and Caroline Kennedy's Tom Kitten.

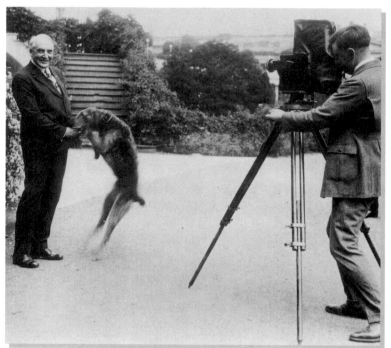

Caroline's kitten adored President Kennedy, who, unfortunately, was allergic to him. That cut short the young cat's stay in the White House: The Kennedys found another loving home for him.

Many famous dogs came before Buddy as well. President Warren Harding's Airedale, Laddie Boy, had his own Cabinet chair, and once gave an "interview" to a local newspaper, discussing a range of topics from politics to working hours for watch dogs. After President Harding's death, newspaper carriers across the country contributed pennies to commission a statue of Laddie Boy for Mrs. Harding.

In her official portrait that hangs in the China Room, Grace Coolidge stands beside her husband's handsome white collie, Rob Roy. President Franklin Roosevelt rarely went anywhere without his Scottish terrier Fala, who even sat at his feet when F.D.R. and Winston Churchill signed the Atlantic Charter in 1941 on the U.S.S. *Augusta* in the middle of the Atlantic Ocean. The Scottie is buried next to Roosevelt at the family home in Hyde Park, New York. Their close

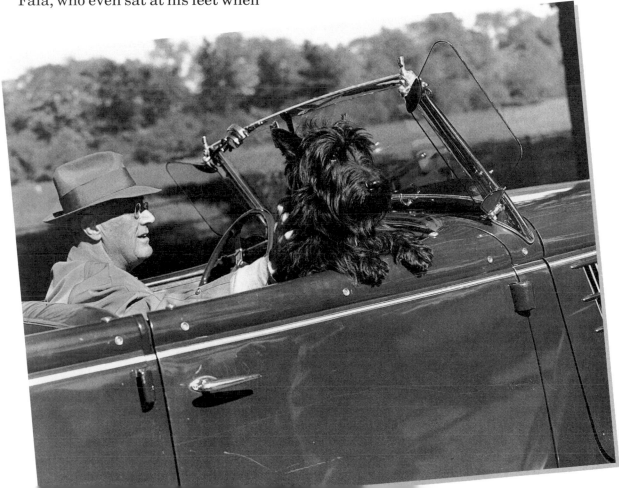

relationship is commemorated at the F.D.R. Memorial in Washington, where a bronze statue of Fala is seated next to one of the thirty-second President. Pushinka was a gift to Mrs. Kennedy from Soviet Premier Khrushchev. A daughter of the first canine cosmonaut to orbit the earth, she mated with Caroline's Welsh terrier, Charley, and their union produced four puppies. Five thousand children wrote to the White House requesting one of the puppies; Mrs. Kennedy selected two recipients on the basis of their letters. Most recently, the Bushes' English springer spaniel Millie became mom to a litter of puppies, including Ranger, in Mrs. Bush's office during her stint as First Dog. She is best known as the first pet

to publish a "tell-all" account of her life, including her years in the White House.

Buddy doesn't seem to have given much thought to his place in history yet. But he has secured a place in the President's heart, and did so the first day they met. Bill is completely at peace around the dog. In the morning, after Buddy has gone for a walk and eaten breakfast, he usually accompanies Bill to the Oval Office. He seems happiest snoozing in the sunny window behind the President's big oak desk made from the timbers of the H.M.S. *Resolute.* And he does get away with some things that other presidential advisers would not dare try. Once, when Buddy decided that he wasn't being paid enough attention, he grabbed hold of his rope toy and started running laps around the Oval Office rug. Fortunately, the meeting with the Vice President and the Chief of Staff had just broken up. Another time, the dog padded into the Oval Office while the President was conducting a foreign policy meeting and jumped up into an empty chair next to Secretary of State Madeleine Albright. (There is no word on whether Buddy offered any advice at the meeting.) On still other occasions, Buddy has received introductions to various heads of state. British Prime Minister Tony Blair was particularly taken with him. Unlike T.R.'s bull terrier, Pete, who is remembered for the time he bit a hole in the trousers of the French

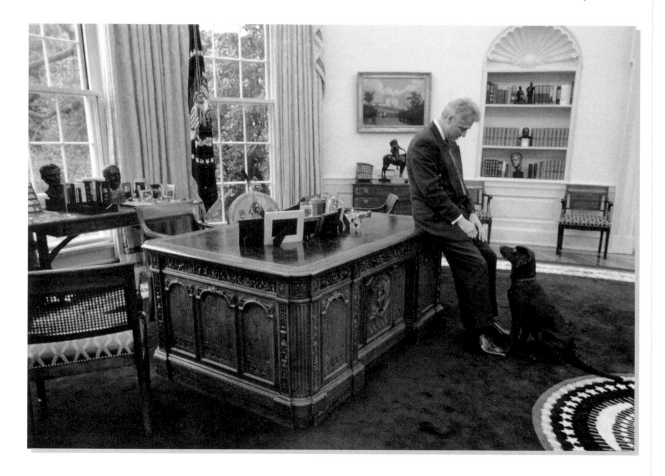

ambassador, Buddy, I'm pleased to report, has proved himself to be the most diplomatic of dogs.

Like Socks, Buddy has the run of only part of the White House. But

the dog has been on a personal tour of some of the White House's most famous rooms, including the East Room. Although it is typically used for events such as dances, dinners, press conferences, and bill-signing

ceremonies, it has housed its share of White House pets. For several months, President John Quincy Adams hosted an alligator that belonged to the Marquis de Lafayette there.

While he loves to wander around, Buddy has always managed to find his way back to the Oval Office, and he seems most at home in the company of the President. When he arrives at the door and finds it closed, he stands patiently outside until someone lets him in. I wish everyone could see my husband beam when "his Buddy" tears down the hall to welcome him home after he's been away for a day or two. Our talented dog has learned to stand on his hind legs, put his front paws on Bill's chest, and give him "kisses and hugs."

Bill often leaves the door leading onto his terrace open so that Buddy can come and go outside on his own. The grounds offer several attractions that only a dog can truly appreciate. I'll never forget the day Buddy discovered that the fountain (the original was installed by President Ulysses Grant in 1871) makes a perfect swimming hole. He loves to cool off in the water and he paddles furiously to stay afloat. He also enjoys whiling away afternoons romping in the English ivy.

At least once a day, Buddy sorts through a bin of toys the Presi-

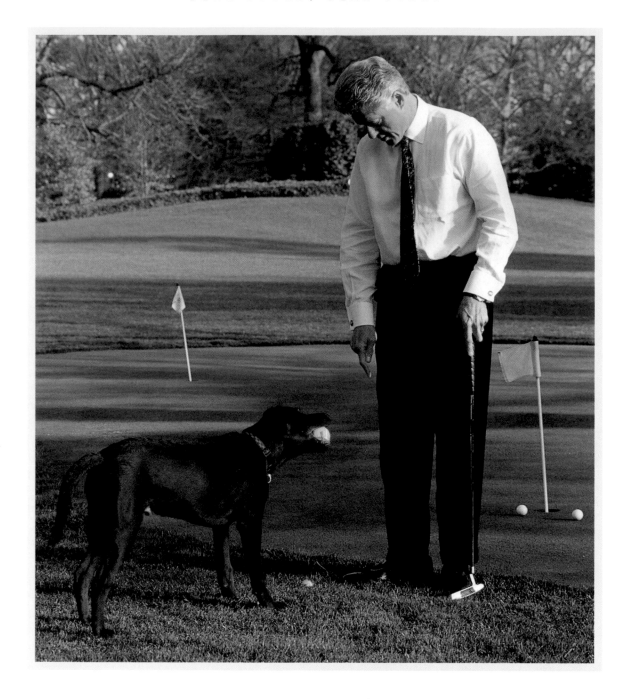

and Buddy wouldn't care. He just starts barking loudly. And he doesn't stop until Bill goes out and plays catch with him. Buddy rarely misses a pitch, whether it's a fastball he snatches out of midair or a bad toss that ends up plunking into the swimming pool. Fetching is a skill at which our dog is not only adept but also inexhaustible.

Although he has tremendous allegiance to the President, he's partial to anyone who throws a tennis ball to him. Buddy doesn't give Frisbees or even golf balls a second glance.

dent keeps for him, gets his ball (it's almost always a little soggy), and throws it down at Bill's feet. My husband has joked that he could be talking to the French president on the phone

Over the years, Socks has willingly shared the South Lawn with many notables. It was there, in September 1993, that Yitzhak Rabin and Yasser Arafat shook hands, and there that Americans gathered to watch the Olympic torch pause on its journey from Athens to Atlanta in the summer of 1996. But I don't think he quite knew what to do when he found out that he would be sharing his space with a frisky dog. When Buddy and Socks met for the first time, both animals were caught off guard. Socks was hanging out in his usual spot behind the Oval Office when Buddy returned from an event with the President. Intent on protecting his turf, the cat hissed and got ready to spring while Buddy, just as taken aback, barked and strained at his leash. Things got so heated between them that Bill and other peacekeepers had to step in. Concerned allies set up several summits in an effort to broker a truce between the pets. It wasn't until the day that Socks swatted Buddy on the nose and sent the puppy off yelping, though, that they began to get along fine. Buddy now seems to understand that Socks is a pretty tough character, complete with claws, even if he does weigh only nine pounds.

Although we love Socks and Buddy and have from the moment we first saw them, we didn't take on the responsibility of our pets lightly. We knew that we had to think carefully about adding them to our family. Some

people get a dog or cat on impulse because it looks adorable in the pet shop window or because they crave the love that a pet can give. But once the novelty of a puppy or a kitten wears off, many animals really suffer. After the movie *101 Dalmatians* came out, the black-and-white-spotted pups became one of the most popular gifts that holiday season. But several months later, what had been the "dog du jour" made headlines because of the alarming rate at which they were being abandoned at animal shelters around the country. It turns out that the cute, cuddly puppies can grow into big, rambunctious, stubborn dogs. That's why it's so important to think of a new pet as an adoption instead of an acquisition. Dogs and cats can live for

ten to fifteen years or more, and it's important to consider whether you can care for them throughout their lifetimes.

We're lucky that we "live above the store" so that we are able to see our pets anytime we want during our workday. Although cats are independent creatures, they still need affection and a human touch. Dogs—especially puppies—require time, care, and an environment in which they can grow and thrive. Rather than leave their pets at home alone all day, many dog owners have recently begun taking their dogs to "day care" centers so they can enjoy the companionship of both pets and people. When we finally made the decision to get Buddy, we were

careful to arrange his arrival to coin-
cide with a break in the President's
usually heavy travel schedule. Bill
wanted Buddy to feel comfortable in
his new home. We were also fortunate
to find a dog that already was well on
his way to being trained.

Being part of our family means that
Socks and Buddy are loved not
just by Bill, Chelsea, and me but by
many people who work at the White
House. They have become good friends
with the White House engineers, who
are on duty twenty-four hours a day.
Socks loves to sleep in their basement
office in a special, red monogrammed
house shaped like an igloo. And
although Buddy has slept in the Resi-
dence since he first moved in, we're

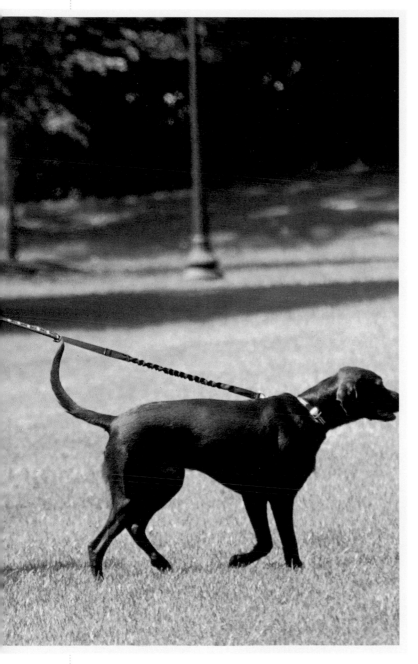

grateful that the engineers look out for him and put him up on the nights we have to be away from home.

The only downside to having so many caring people around is that Socks and Buddy have a difficult time turning down their hospitality. It didn't take Socks long to develop a paunch from devouring all the treats the staff offered him. Buddy also loves to snack between meals— especially if he gets hold of peanut butter. Since being overweight is just as much a health risk for pets as it is for people, the vet put both of them on strict diets.

Whereas Socks really is a home-body who prefers the comforts

and familiarity of the White House, Buddy has a taste for travel. His first family vacation was our New Year's trip to Hilton Head Island, South Carolina, and then to the Virgin Islands. Buddy, not Bill, was the one who called the shots on that trip. The President had to carry the dog down the mobile staircase off Air Force One. Now that the puppy has grown into more than an armful, I think Bill is grateful he's got the hang of going up and down steps. He flies with us on the President's helicopter, Marine One, whenever we go to Camp David. There, like my husband and me, he uses the weekends to unwind. Then, he's refreshed and ready to face the demands of his Washington life again.

What amazes me about both Socks and Buddy is how temperamentally suited they are to living in the midst of the commotion and activity that goes on around the White House. Although there are thousands of visitors, our cat and dog lead as normal a life as possible. Neither animal keeps an official schedule. When they do make a special appearance, they seem always to rise to the occasion. Socks, especially, likes to pose for pictures. While he has an uncanny ability to sense when someone of any age needs a little extra attention, one of his most endearing traits is the extra bit of patience he musters for children. Once, while he was out on a walk, Socks passed by a group of people waiting to tour the White House. He surprised

and delighted a young woman in a wheelchair when he jumped up into her lap.

Among the frequent visitors to the White House are children and their families sponsored by the Make-A-Wish Foundation and other organizations that help youngsters suffering from life-threatening illnesses fulfill their fondest dreams.

They're often as thrilled at shaking the paws of Socks and Buddy as they are at meeting the President. We also invite a group of mobility-impaired visitors to tour the White House when it's decorated for Christmas. Meeting our pets always turns out to be a first for at least one or two kids in the group who have spent their lives in long-term care facilities and have never experienced the joy of stroking a soft, furry animal.

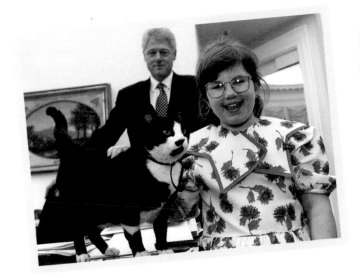

Many people these days have started to recognize the calming effect pets have on people. When Bill takes a break from his work to toss a ball to Buddy out in the Rose Garden, it helps him to relax. Studies have proven that pat-

ting an animal can lower blood pressure. Researchers also say that pet owners visit the doctor less often and live longer. Pet ownership can even qualify senior citizens for savings on their insurance. Animals known as pet practitioners are beginning to play a larger role in many kinds of patient therapy. When young victims of abuse find adults too threatening, an animal can be the perfect listener to help them begin talking about their experiences. The Delta Society, a nonprofit organization based in Washington State that has fostered this two-way relationship between people and animals, celebrated some of the animals in a nation-

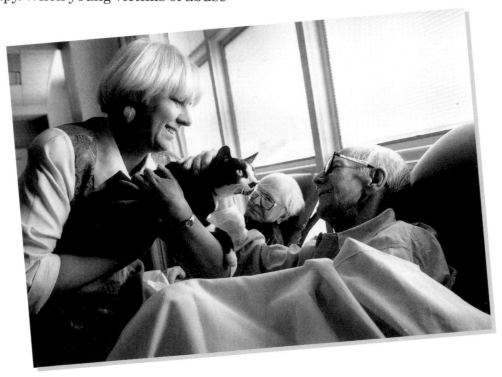

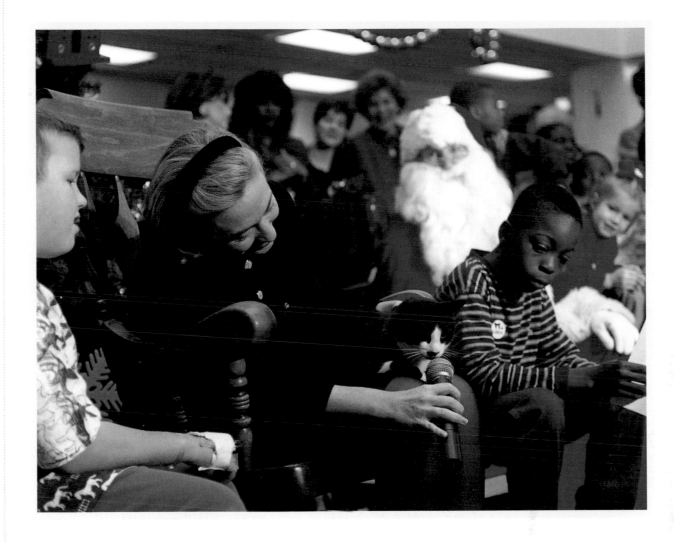

ally televised awards ceremony in 1998. An ex–Easter Bunny named Dusty received an award for his work in helping children in a burn unit regain confidence in their sense of touch, while Splash the Stingray was recognized for motivating a boy with cerebral palsy to use his legs. Three

cats named Buster, Flashback, and Flame were acknowledged for their special friendship with residents of a nursing home.

Encouraged by the example of these animal colleagues, Socks likes to visit hospitals, nursing homes, and orphanages around Washington, D.C. Seeing a friendly pet can make a sterile institution seem a little more like home. It's there that Socks has proved his real star quality. He sits in my lap and purrs while I read stories to the children, and he doesn't mind when little hands reach out to pet him. He especially likes to be scratched behind the ears. He's also taken drives out to the U.S. Soldiers' and Airmen's Home to thank the volunteers who work so hard helping Buddy and him answer their mail.

For the first year, Buddy was too young to accompany Socks on any of his goodwill jaunts. But as he matures, he's proving himself to be especially gentle around babies, whom he loves to nuzzle.

Although kids have a natural affinity for animals, they need to be taught that along with the licks and snuggles that a cat or dog gives so freely comes responsibility. Taking care of a pet is something that families can do together. Children love making sure there's water in the bowl for their furry friends and that they're properly fed.

When we moved to Washington from Little Rock, we brought our family traditions, favorite pictures, and personal mementos to make the White House feel more comfortable. But it wasn't until

Socks arrived with his toy mouse and Buddy walked in with his rawhide bone that this house became a home.

Pets have a way of doing that.

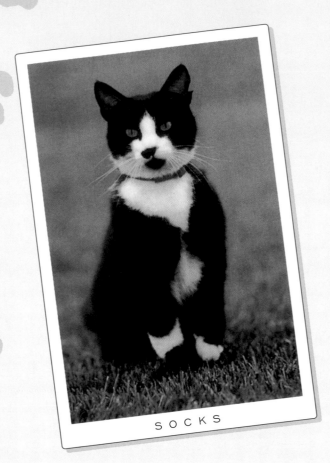

SOCKS

Socks Stats

Type of cat: Domestic short hair

Date of birth: Unknown

Member of the Clinton family since: March 1991

Height (head to paw): 14½ inches

Weight: 9 pounds

Tail length: 1 foot

Color: Black with white markings

Eyes: Yellow-green

Favorite activity: Taking a catnap

Favorite bug to catch: Spiders

Least favorite color: Chocolate brown

Favorite hideout in the White House: In a chair outside the
 Oval Office

Buddy Bio

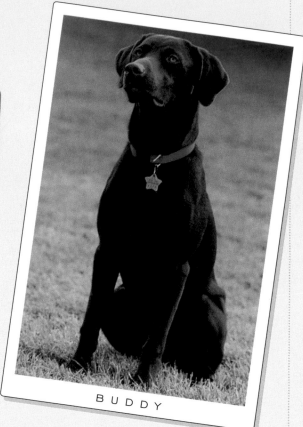

BUDDY

Type of dog: Labrador retriever

Date of birth: August 7, 1997

Member of the Clinton family since: December 1997

Height (head to paw): 31 inches

Weight: 68 pounds (and still growing)

Snout length: 5 inches

Color: Chocolate brown

Eyes: Hazel

Favorite activity: Chasing tennis balls and chewing on them

Favorite bug to swat: Flies

Least favorite colors: Black and white

Favorite hideout in the White House: Behind the President's desk

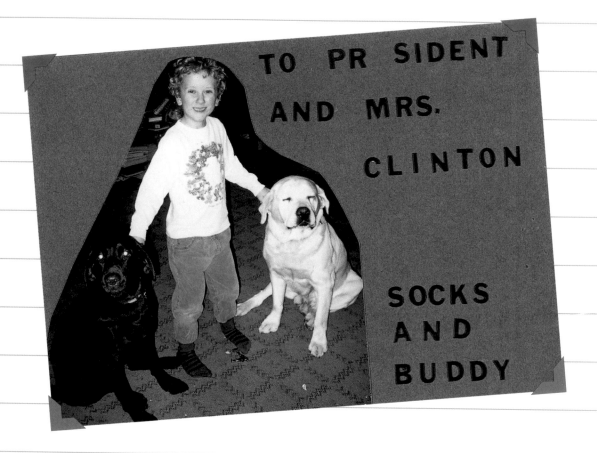

Dear President and Mrs. Clinton;

 I know how very busy you are, but I hope you are able to look at this note. I and my family send our best to you and your family, a special hello to Chelsea.

 Thank you for your time;

 Logan Gittelson

My name is Logan Gittelson, I am a 6yr. old boy.
Since I was 3 yrs. old I have really liked you. I
would see you on tv. and yell—Hey look—President
Clinton or if I saw your wife I would say, President
Mrs. Clinton. (Now I just say Mrs. Clinton) I also
have postcards of you and your family on my
refrigerator.

I need to go back to the hospital this summer to
have surgery again. They need to close a hole in my
heart. Mom and Dad say I'm their miracle child.

Special message to Socks from Dharma and Greg—So how's it going with Buddy? We know how you feel, we have two Labs. to deal with here.

To Buddy from Chimo and Mocha—We like seeing a Lab in the White House!!!

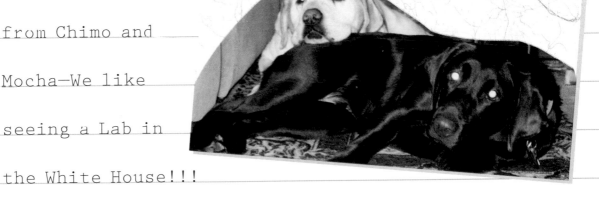

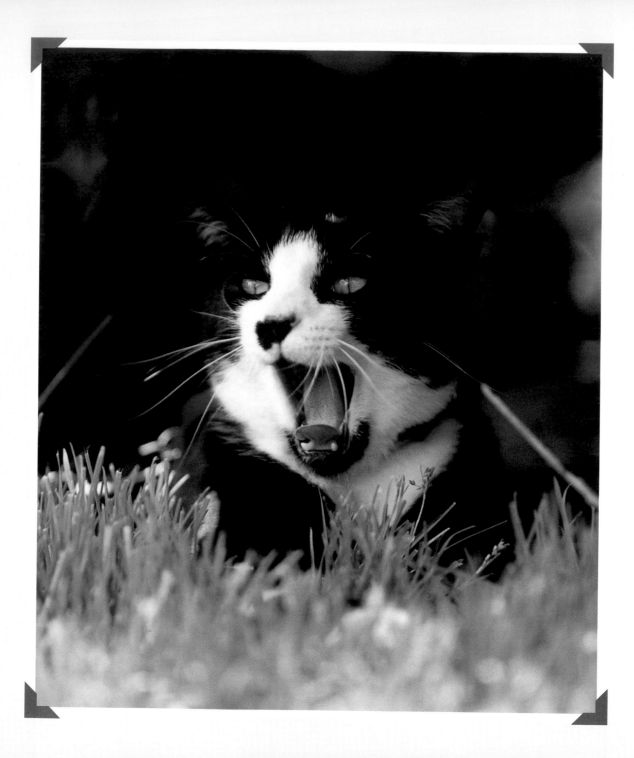

Dear Socks,

Your one cool cat, and I am pleased to be writing to you. Do you think I may have an autographed picture of you. I would keep it on my bookshelf with an alarm on it for all my life.

Thank you for reading my letter. Please write back. Hope to hear from you soon.

Your friend

Michael Carter

Dear Buddy,

I have two dogs. How do you like being a dog, Buddy?

I like being a person.

Could you send me a picture of yourself?

Your friend,

Sam Bradman

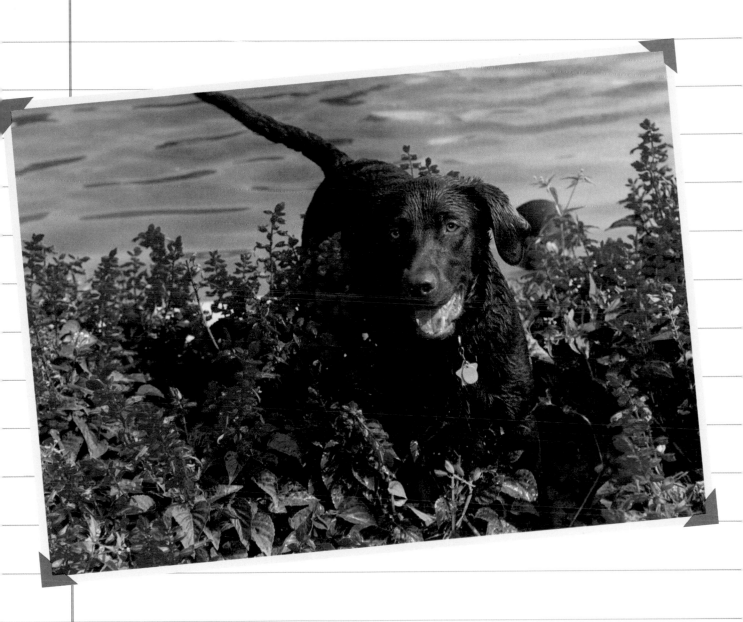

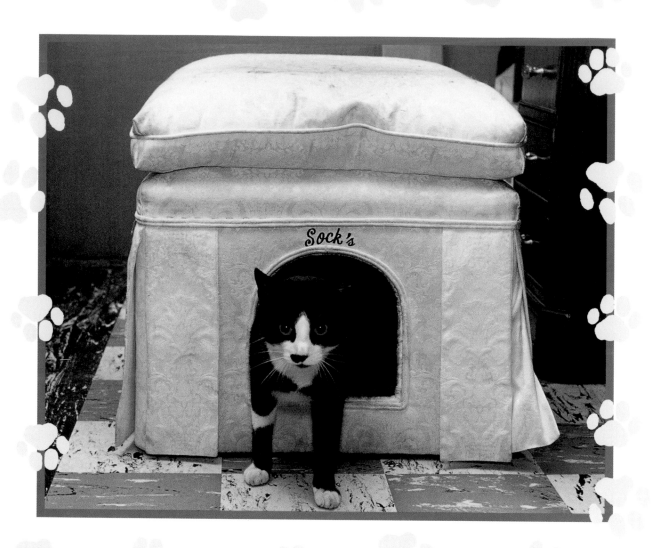

Dear Socks

 My name is Justin Barton. I am 9 years old. I like basketball. What catfood do you eat? Does Buddy ever chase you? Do you like the White House? How does it feel to be top cat? Do you like buddy? Do you have press conferences with other leader cats? Where is your cat box.

 From,

 Justin

Dear, Buddy and Socks,
I'm Alexa. I'm 7 years old. I
like dogs and cats. Can I have
a picture of both of you? The
President is lucky he has you!

Love,

Alexa Szelc

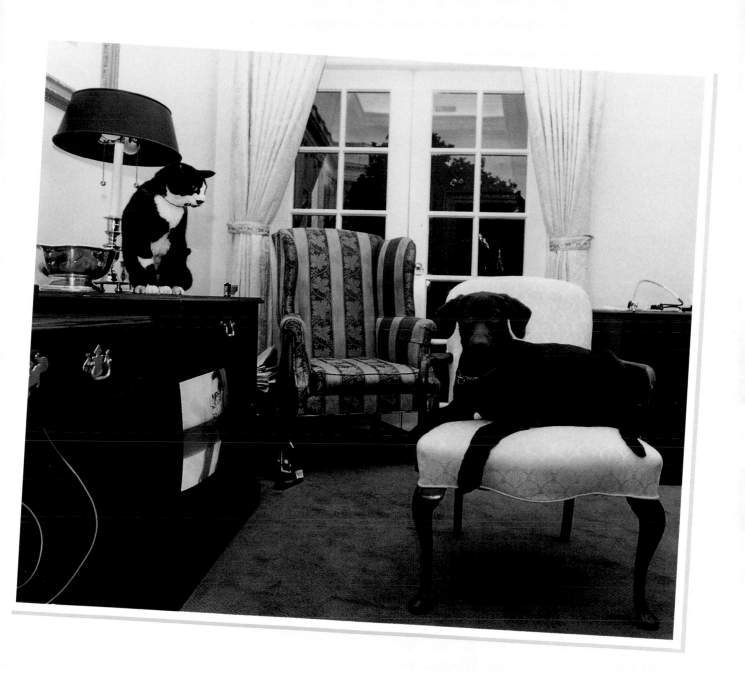

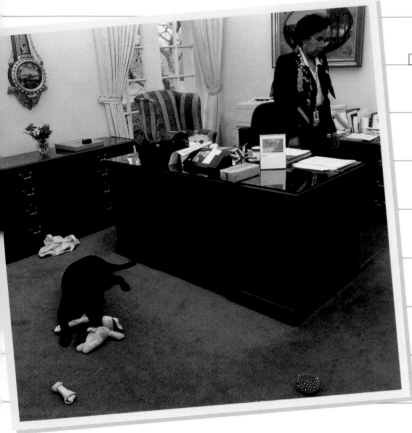

Dear Buddy,

I am 10 years old
and I have 2 puppies
and 2 Older puppies.
They are all black
except one. His coat
color is the color
of a lion. His name is Simba. The other little
black puppies name is Shadow. She is a girl. One of the older
puppies name is Buck. He is a boy. When the puppies were born
he was the biggest. The other older puppies name is Runt she

was the smallest when she was born. How old is Socks and how

old are you? Can you do any special tricks? Do you act special

since you are the presidents dog? Will you write me back and

send me a picture of Socks and a seperate picture of you and

will you sign it?

 Your friend,

 Justin Blake

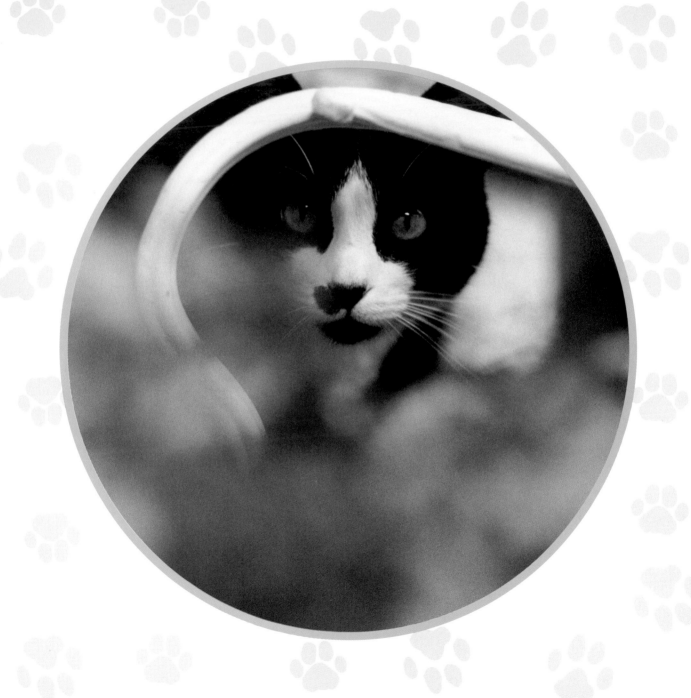

Dear Socks,

How does it feel to live in the White House? What is you're favorite hiding place in the White House? Do you shed alot? Does the president drink alot of coffee? He might want to switch to decafe!

Ha! Ha!

your friend,
Anna Campbell

P.S. write me!

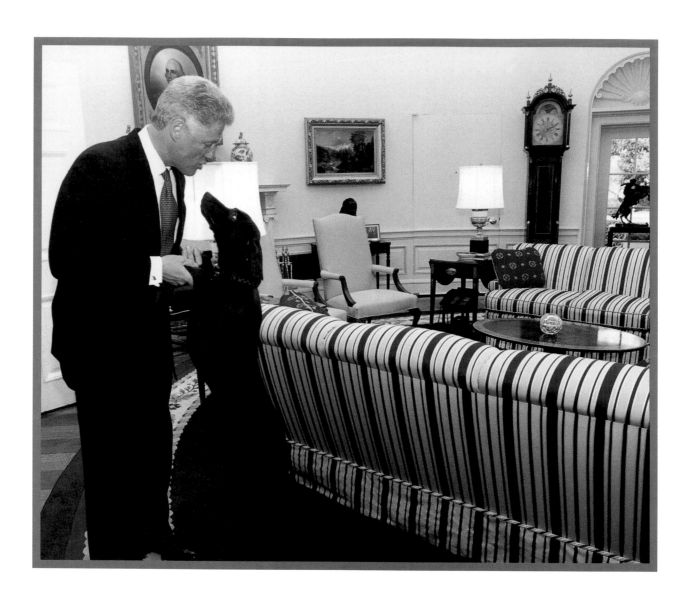

Buddy, The First Dog
The White House
1600 Pennsylvania Avenue
Washington District of Columbia 20500

Dear Buddy:

I've heard ...that... you're the first dog. Does this mean you have authority over the other dogs of the United States? What about other nations? Do they have specific titles for a dog that belongs to the ruling human or humans of that nation?

Well, I've asked a lot of questions so maybe you can get your master to answer them and give me an autographed picture of you and your rival, Socks. Thank you very much. I'll understand if you can't do it.

Very truly yours,

Karen Kay Powell

Ms. Karen K. Powell

Dear Socks,

Are you happy with Buddy? Would you rather be without Buddy? I have two cats. One named Friskey and one named Smokey. Last night I watched Garfields feline Fantasy's. Do you like Garfield? Do you know Garfield? He is a fat cat that doesn't now what is chew! Last year in seconde grade I did a report on cats! Did you know that cats are my favorite kind of animal. I hope you're doing fine.

Your Paw matched friend,
Kerry Guyer.

P.s. Here is a song my mom made up.

The cat wants in,

The cat wants out,

The cat wants to get up and shout,

Meow!

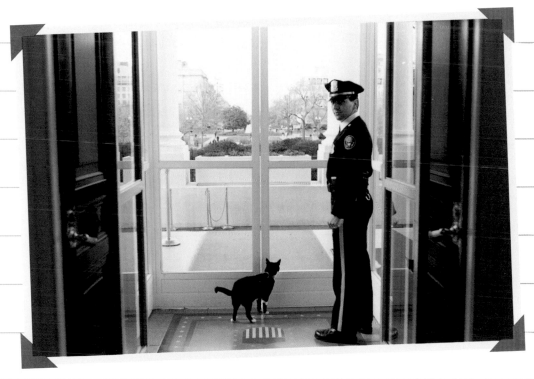

Dear Buddy,

What does it feel like to be the President's dog? It must feel neat. Did you ever get petted by the Spice Grils? Do you like haveing a cat live with you? I have a dog and a hamster I want a cat but my Dad dons't. What's your favorite person that lives with you? What's your favorite food? I onece ate dog food. I didn't like it. How is Socks doing? Tell Socks I said Hi. Buddy will you send me a picture of you it would make me very happy and can you send me a picture of Socks if it's OK with you?

yours truly,

Alicia Wagoner

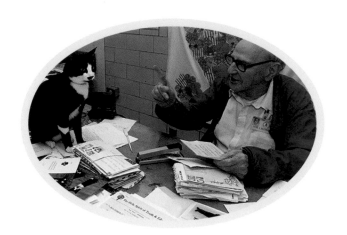

Dear Mom, Dear Dad

A FEW SUGGESTIONS ON

HOW TO WRITE WITH YOUR CHILDREN

The written word faces some pretty stiff competition these days. Who doesn't reach for the telephone instead of writing a letter or click on the television rather than picking up a newspaper? Even when we do write, it's often just a short note or e-mail message. We live in an age when we prize both information and immediacy. But it's precisely because we're in such a hurry that thoughtful writing is more necessary and valuable than ever.

Bill, Chelsea, and I have always been a family of writers. When our daughter was small and I had

to go away on trips for a day or two, I would leave little messages for Chelsea telling her how much I loved and missed her. And lots of times I would leave a trail of written clues. When Chelsea got to the last one, she would find a surprise waiting for her. A few years later, when she was in elementary school, Chelsea and Bill shared a daily ritual of exchanging letters. One big benefit was that it helped Chelsea practice her language skills. But that's not what made them take the time to sit down with pen and paper. They did it because it was important for them to catch up on everything that excited or troubled them, especially when they didn't get to spend enough time together.

Of course, children don't have to grow up to become journalists or novelists or receive the Nobel Prize in Literature to enjoy and appreciate writing. What is important is that they learn to engage in and be engaged by all different forms of writing, including poetry, journals, stories, essays, and letters—like the boys and girls who contributed their letters to this book. And there are many things that moms, dads, grandparents, big sisters, big brothers, and even caregivers can do to encourage children to write.

Why emphasize writing? Literacy is not just about reading; it is also the ability to communicate effectively. More parents have begun to recognize that reading and talking to their chil-

dren are among the best ways to prepare them to do well in school. The same goes for the other aspects of language—listening and writing. Each element helps youngsters develop their own vocabularies and learn to make good decisions about grammar, organization, and style. Writing also helps to shape understanding. It helps us see concepts more clearly and to develop thoughts and values. Together, reading and writing are essential developmental building blocks for all kinds of other higher-level thinking and tasks.

Reading and writing are not only closely allied, but they support each other. Through reading, we learn language that we use when we're writing. And while we used to think that children had to learn how to read before they could write, more recent research shows that those who grasp writing also improve their reading more quickly.

Besides helping us become better readers, writing helps us think independently and creatively. Often, until we sit down to a blank sheet of paper or a computer screen, we don't know what we have to say. And it's not just professional writers who need to generate and develop ideas, it's each of us. For me, writing always has been one of the best ways to collect my thoughts. Until I have to sit down and actually commit pen to paper, ideas tend to tumble around in my brain

without any particular organized pattern.

Lucy McCormick Calkins, the founding director of the Teachers College Writing Project at Columbia University and the author of *The Art of Teaching Writing,* notes in her book, "By watching us, children can learn that writing is not only doable, it is also worth doing." In thinking about ways to help children read and write, I found both information and inspiration in Calkins' book. I also drew on publications available through the U.S. Department of Education, which I've listed in the back of this book.

When we read the newspaper and talk about the comics, sports, or current events with our children, tell them about a favorite book, send a thank-you note, or record what we're growing in the garden or what we saw together at the zoo, we convey the message that writing has value in our lives. We show our children how to be writers.

What else can we do? One way to start is by giving our children their own supply of paper, notebooks, pencils, markers, and crayons to keep with their toys and around the house. Children can also see what the alphabet looks like and how to form words by playing on a computer. And there is room for writing in almost every activity, even in the world of make-believe. If they want their stuffed animals to

come for tea, suggest they send out invitations. If they're playing "restaurant," let them take down your order for a hamburger and fries. Before they learn to write, have them dictate thank-you notes to you so that they develop good manners and good writing habits themselves. As your children grow older, playing Scrabble or hangman or working on a crossword puzzle together helps them become better readers and writers. It's also a good idea to keep a journal together. Parents who are pressed for time, as we all are, can involve children in helping to make a shopping list and share a few lines about their day, as Chelsea and Bill did. Grandparents also make perfect pen pals. This strengthens the bonds between gener-

ations and helps children understand the connection between writing and receiving letters.

Researchers are also finding that children can begin writing earlier than we traditionally thought. Just as babies begin to "talk" by making unintelligible sounds, they begin to "write" by making scribbles and pictures. And they take to it naturally. I remember that before I started school, my mother and I would spend hours having picnics in the backyard, pointing out the shapes of animals and the letters of the alphabet that we would find in the clouds. And I did the same thing with Chelsea. What is good about this game is that it's portable. Parents and children

To. Dear Socks,
What is it like to live in the
White House? Do you miss
Chelsea? Does she like Stanford.
Do you mak ...esident
Clinton sneez
sleep..? Love

Dear socks & buddy
I hope that you are
friends. Socks hope
you don't like fish
cause I have some.
I live in Hilton Head,
S.C. Mayby you all
would like to come
here! Love, Taylor
P.S. Can I get
picture of you all
please.

Buddy,
my name is Hayley
... I have blond hair
blue eyes and two fat
... I am in 4th grade
just turned ten.
my birthday I went
my friend Anna's
to play with my
do Anna and Wednesday.
Anna and Robin
to my house. So I
curios what kind of
are you? And please
... me a picture of
Your friend,
Hayley

... is Grey Kohl I am
... to Barry School. I'm
... teacher is the ever
... Mrs. House. Her
... be in. I have blond
... yes.
... ret service cars bug
... been on Air force
... but it died. It was
... get me a job in
... do you feel about
... oes Bill Clinton
... entian to you or
pay more attention to you or
buddy? How do you like
the best Chelsea Hillary a
Bill? Do they have the
picture of you in the ever
White House. have you ever
seen the Goast of Lincoln.
Sincerely,
Gregory Kohl

can pick out certain letters in street signs as they pass by in a car or in advertisements while they're riding the subway together.

Chelsea also loved to scribble with her crayons and then tell me the stories she had written. Sometimes we even wrote the stories down together and I would read them back to her. When they see their words on paper this way, children get a feeling for the power of language. It makes them more confident when they pick up a pencil or sit down at a computer to write.

Like the correspondence in this book, children's early attempts at writing do not have to be perfect.

The important thing is to get kids writing. Over time, you can gently correct their spelling and grammar, but, especially at first, try not to be too critical. Our job is to help children get started and to encourage them to keep going.

The young authors whose letters are collected here, as well as thousands of others who wrote to Buddy and Socks, already have begun to learn a lifelong lesson about writing. Not only have they experienced the pleasure of expressing themselves, but they also have begun to understand that, like our Constitution, whose strength continues to endure, ideas have power and permanence when they are written down.

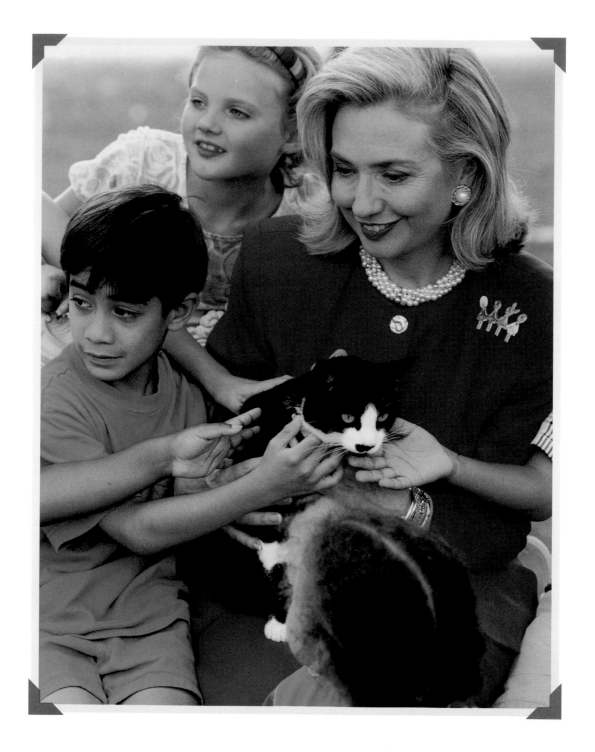

Dear Socks,
 Hi! My name is Greg Kohl I am
ten years old and I go to Barry School. I'm
in 4th Grade my teacher is the ever
Popular beautiful Mrs. House. Her
class is fun to be in. I have blond
hair and blue eyes.
 Do those secret service cars bug
you? Have you ever been on Air force
one. I had a cat but it died, It was
sad. can you get me a job in
the Fbi? how do you feel about
buddy? who does Bill Cinton
pay more attention to you or
buddy? How do you like
the best chelsea Hillary
Bill? Do they have a
picture of you in the
white House. have you ever
seen the Ghost of Lincoln.

 Sincerely,

 Gregory Kohl

Dear Buddy,

Hi! My name is Everett S. Kirk IV. I go to Shawnee
Maplewood and I'm in fourth grade. I have two dogs
and they have seen you on TV and loved you.

I know you can't read this but I'm sure someone
can read this for you. I was just wondering what it
would be like to be a animal for the Clintons? Do you
have your own dog house or do you sleep with
anyone like Socks or Chelsea? What kind of dog food
do you eat so I can get my dogs too try it?

When my dad goes to the YMCA he signs in as Bill

Clinton but they know his real name. so they call my dad Bill, my mom Hilleary, my sister Chelsea, my other sister Socks, and me BUDDY. My sisters and my dad call me Buddy just like you!

Animal lover,

Everett kirk

P.S. Can I have a picture of you.

Benjamin Lear

Dear Mr. president and Mrs. Clinton,
Thankyou for inviting my family and I
to the White House. It was a great experience
I'll never forget and I loved it. I thought
putting on your putting green and dinner
was great. P.S. Buddy and Socks are great

Love,

Ben.

Benjamin Lear

Dear Buddy and Socks,
Socks, I loved petting you and hearing
you purr. Buddy, I loved playing fetch
with you. I think you'ld make a nice baseball
player. Here's a poem I wrote. I'm
dedicating it to the two of you.

Love,

Ben.

Nature

By Ben Lear
September 24, 1997
Now Dedicating it to
Socks and Buddy

Nature is as beautiful as the Pegasus landing in
its vertical ways.

It is like the eye of the eagle swooping down to
catch its prey.

It is what we people see but don't understand
because we haven't passed the test, the test
that proves we know how to take care of this
world.

Nature feels like magic, when you're in the
middle of the forest looking up and seeing
pieces of the sky through the trees.

The pieces of the sky look like an unsolved
puzzle that God wants you to solve.

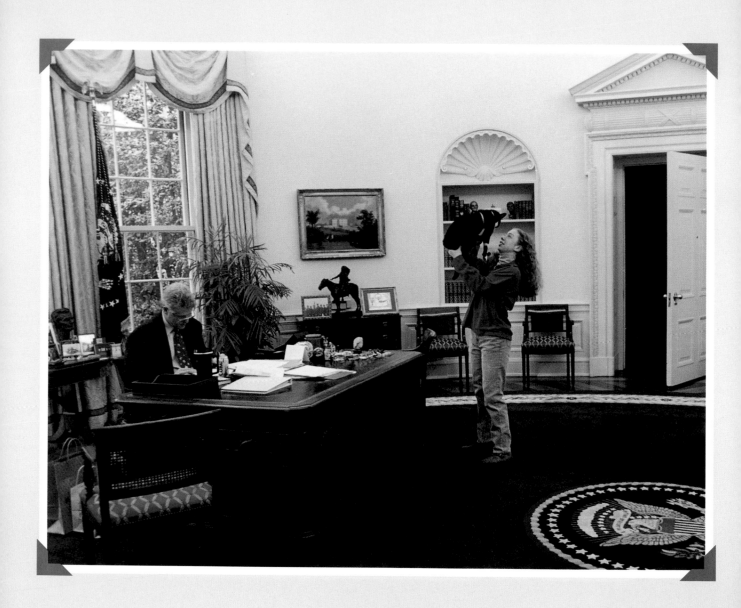

Dear Socks,

I Absolutely love cats, and I think your the cutest cat I ever saw. How are you? I'm doing fine. How are Mr. and Mrs. Clinton? Do you miss Chelsea since she's in college, and are you and Buddy geting along? Shoo! I wrote a lot of questions, didn't I? There goes another question. Bye!

P.S. Write soon.

Your fan,
Ryan Jones

Dear Socks and Buddy,

My cat is a big fan of you Socks, But I think Shes afraid of Buddy. Me and my cat would like to have both of your paw prints.

from,

Chrissy & Bootsie

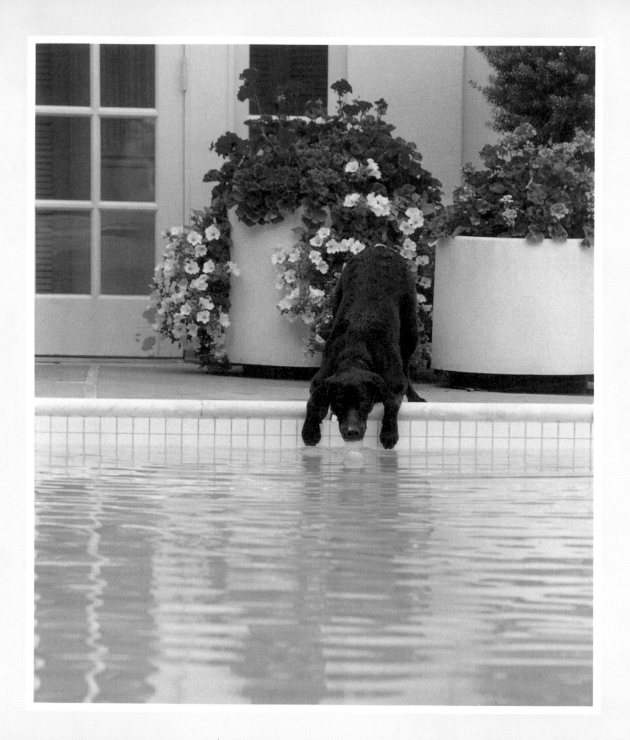

Dear Socks,

Is it nice living at the Whitehouse? I used to have a Dog but we had to sell it because it scratched a little boy on a tricycle then the police officer.

From,

Willy

DeCamp

Dear Socks,

I read a book called *Socks*. It was about a cat named Socks that had some silly, but wild, adventures. One time he fell into the mail box. Well, anyway, I was wondering if that is why your name is Socks.

I would like to have a cat, but my mom is allergic. I was wondering if you could send me a picture of you with your paw print on it. I would also like a picture and autograph from your owner Bill Clinton, too. Thank you.

Yours truly,

Matthew Modula Jr.

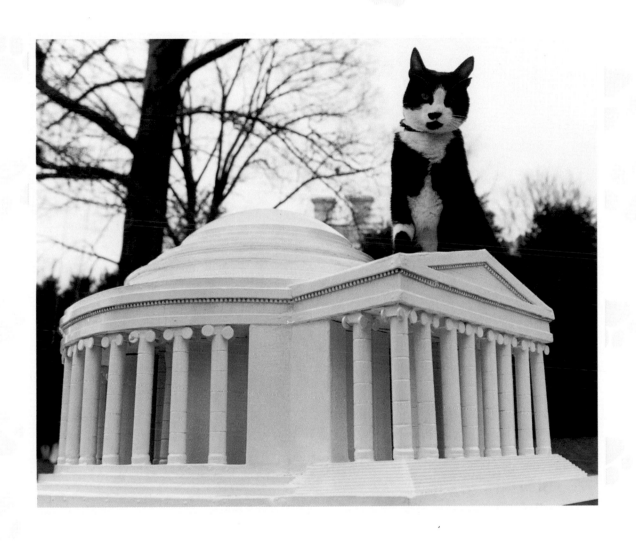

Dear Socks:

 I am Julia Echternach. I am nine years old. It seemed like fun to write to the President's cat, so that's why you have this letter. (It's okay if you don't have time to answer somehow.)

 I got your address (and William, Hilary, and Chelsea Clintons') from an American Girl magazine. Do you know what? Whenever I see pictures of normal people who live long ago, I think they're lucky to have THEIR pictures chosen. I always send things to that magazine, hoping I'll get published. I want to be a writer when I grow up.

 Your picture was in the magazine. You remind me

of Figment, my friend Kelly's kitten. I think Socks

is a good name for you. All cats are very adorable. I

have a cat named Milo. He is a very cute cat. On some

cat calendars I have, the cats and kittens are cute.

How do you cats make yourselves appear so adorable?

I know cats can't write, but I have some questions for you.

What is the White House like? Of course it's big, but is it spooky or nice or too fancy? Or just right? You are a lucky cat to live in such a big house. Plenty of sleeping places. Milo gets cat fur on everything when he sleeps. Once I had a piano recital, and it was winter, so I needed my jacket. My jacket is all fuzzy inside, so fur can easily attach to it. Milo had slept on my coat recently. Because my mom didn't want my dress to have any cat fur on it, I had to take off my coat after I realized the fur was there.

As a coincidence, Milo walks across our piano sometimes. Do you have any pianos to "play"?

Those may seem like silly questions, but at least try to answer them. Please! Have someone else write a letter for you, maybe—they might be able to answer the questions. If you don't have time to have ANYONE write back, that's okay.

Have a nice holiday season! Don't chew open anyone's Christmas presents, or people might get mad at you. You probably don't want that!

Sincerely,

Julia Echternach

Dear Buddy,

Hi! My name is Danielle. I'm 9 years old. How does it feel living in the house of the big man? I'd love it. I have a dog. Her name is Nessie. We named her after The Lock Ness Monster. If you could, write back.

Sincerely,
Danielle Mayes

P.S.
Could you send me a picture of you and Socks. Well Bye for now.

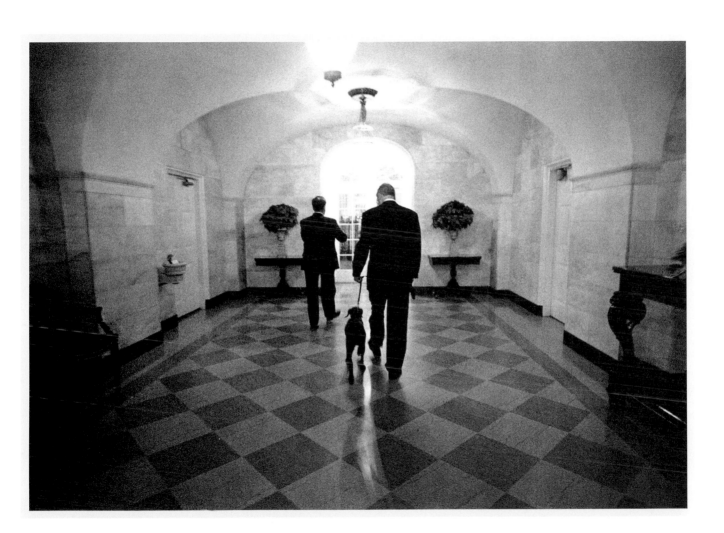

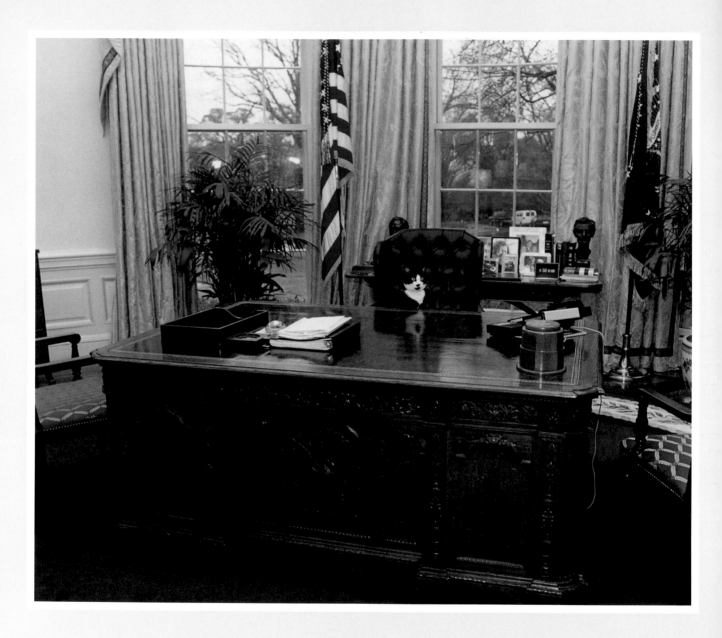

Dear Socks,
Where do you sleep in the White House? Do you get paid for being the first cat? What do you do all day?
Love shelby

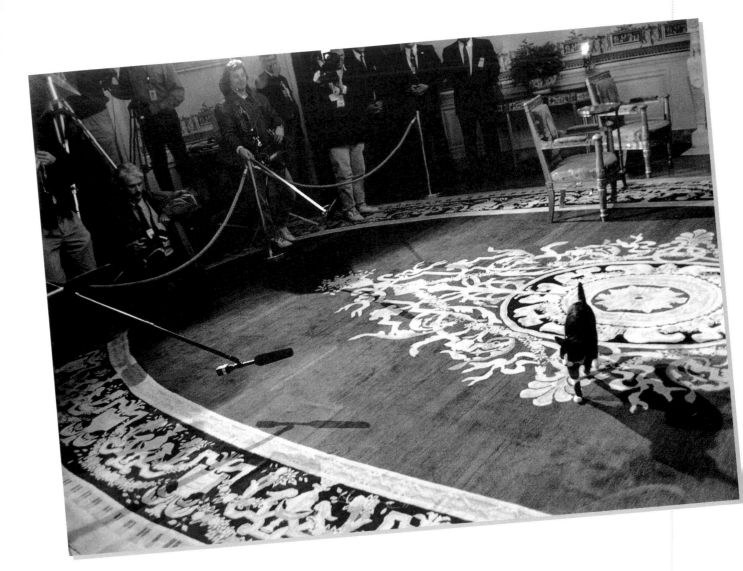

Dear Socks,

Socks' pen pals are curious about how our cat spends his days in the White House. Here's a glimpse of the First Cat's life as I see it.

1 Do you have your own room?

Socks has a lot of favorite napping spots around the White House, but at night, he usually retires to his bed in the engineers' room, where there's always someone awake to keep him company.

2 Are there any good mice in the White House?

I've never seen one. Maybe that means Socks is doing his job.

3 Do you miss Chelsea since she's in college?

Socks definitely misses Chelsea, but he just couldn't bear the idea of dorm life. Fortunately, he has a lot of friends around the White House who help take good care of him.

4 Do you like having Buddy around?

Socks ignores the dog as much as possible. He just keeps waiting for Buddy to go back where he came from.

5 Do you have room service?

Although Socks doesn't know how to use a telephone, he can nibble whenever he wants. We keep dishes of food and water for him outside under his favorite shade tree as well as near his bed inside.

6 Do those Secret Service cats bug you?

No. Socks just wishes he could talk into his paw the way they talk into their sleeves.

7 Have you ever seen the ghost of Lincoln?

Socks is still hoping. Historians say that cats were President Lincoln's favorite animals, and he often picked up strays.

8 Do you get to ride in a limo?

When Socks goes to visit children and senior citizens in local hospitals, orphanages, and nursing homes, he travels in his own carrying case that bears the Presidential seal. He has ridden in a limousine at least once and often has been part of motorcades.

9 Do you have press conferences with other leader cats?

Socks made all the papers when he was still "First Cat–elect," living at the Governor's Mansion in Little Rock. Generally, though, he shies away from publicity and prefers for his actions to speak for themselves.

10 What is your family name?

Socks has been a Clinton ever since we found him in Little Rock and adopted him as part of the family in 1991.

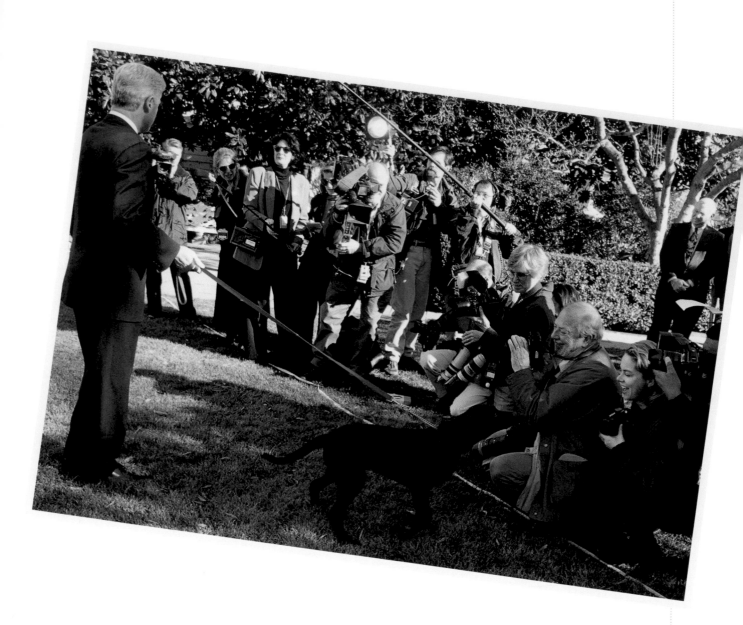

Dear Buddy,

Children want to know all about the First Dog's habits, daily routine, and even his aspirations in life. Although I can't speak for him, here's how I see our dog.

1 Do you chase Socks?

Buddy has pretty much left the cat alone since the day Socks took a swipe at his nose. Now our pets live together peacefully, albeit at tail's length.

2 Do you bark
a lot?

Buddy does bark (and loudly),
especially when he's trying to get the
President to pay attention to a very
important matter—tossing his
tennis ball.

3 Do you get to go anywhere
you want in the White
House?

Buddy usually spends his days in the
Oval Office with the President or play-
ing on the South Lawn. At night, he
sleeps in the Residence with us. He has
toured the Red Room, the Blue Room,
and the Green Room, but he was on a
leash. He also doesn't like to walk on

the marble floors by himself—his feet
slip.

4 What's the weather like
in Washington?

In the summer it's hot and humid. And
about half the time it rains like cats
and . . . Need I say more?

5 Can you do any
tricks?

Buddy can sit, shake, lie down, and
come when you call him. In just a few
months, he has trained the President
to throw a ball and to stay off his
favorite chair.

6 When you grow up what do you want to be?

I don't think he's decided yet. After this book, perhaps he'll consider becoming an author.

7 What is your favorite food?

Buddy loves all kinds of people food, but it's not good for him. He eats dog food twice a day, and we keep several bowls of fresh water for him in different places around the White House.

8 Do you have any toys?

The President keeps a bin full of toys for Buddy. Every morning, Buddy dumps them all out and spreads them all over the floor until he picks out the one he wants.

9 Do you have a best friend?

While the President is our dog's No. 1 buddy, he has many friends—most of them people.

10 Have you ever been on Air Force One?

Any plane the President rides on is called Air Force One, but Buddy hasn't yet made it to the "big" plane.

Dear Buddy,

 I think you are very cool. I want to know where do you sleep or stay? Do you get to go to alot of places? I'm 10 now I want to be vice president for my class. Do you like the White house? I like dogs. Do you like the cat Sox? My favorite sports are WWF wrestling and baseball. My favorite wrestler is Stone Cold Steve Austin. My favorite baseball team is the Yankees. My favorite player is Berrnie Williams. I have a dog her name is Horace and she is a golden Retirver. Also, I have a cat named Taz She is black, white, and gray. She is lazy too.

 Sincerely,

 Jon Smart.

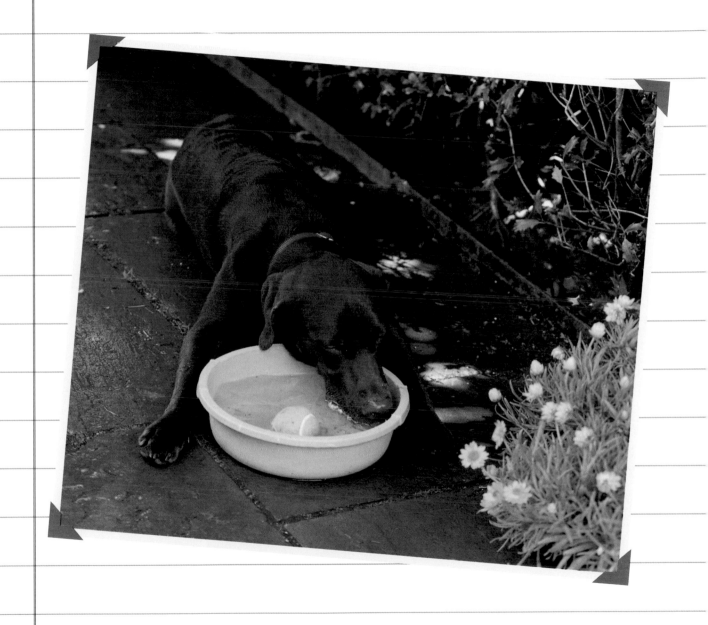

Dear Buddy,
My name is Hayley Napier. I have blond hair and blue eyes and two fat bulldogs. I am in 4th grade and I just turned ten. On my birthday I went to my friend Anna's house to play with my friends Anna and Wednesday. Then Anna and Robin came to my house. So I was curios what kind of dog are you? And please bring me a picture of you.

Your friend,
Hayley

Dear Socks (and),
 I have some questions
for you. Are you aloud to watch
MTv. I am? Do you have
a favorite food I do.

 Sincerley,
 Ross Rankin

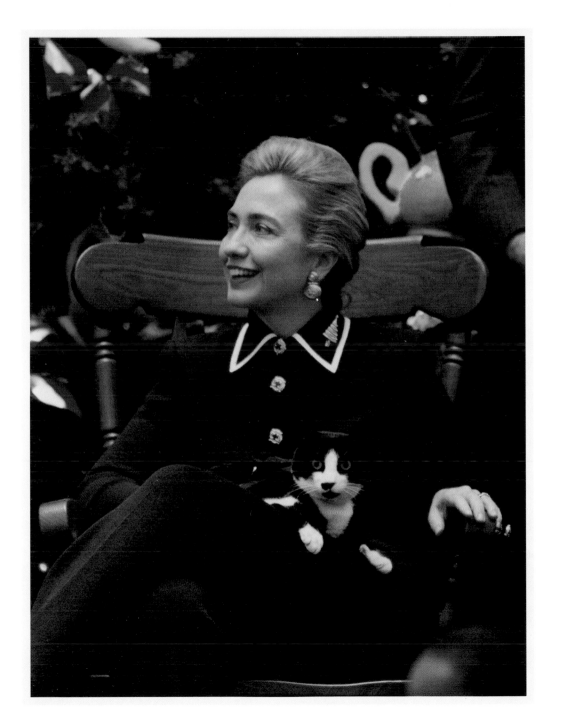

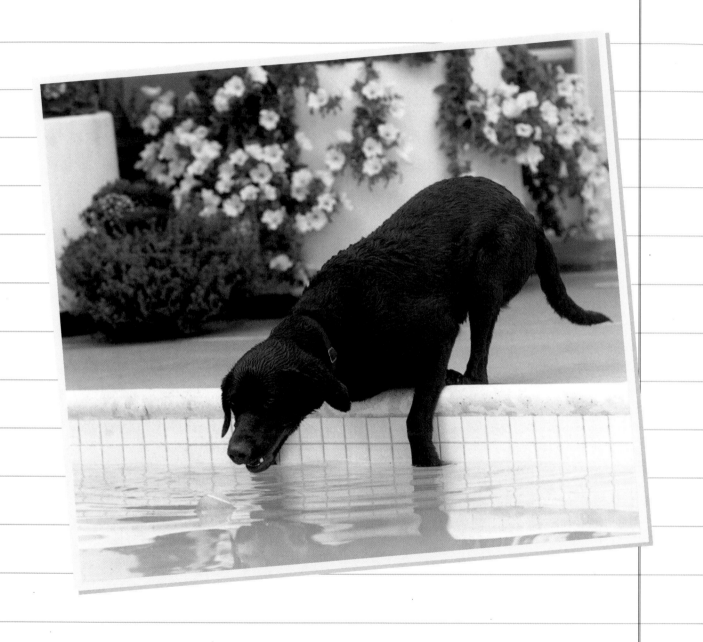

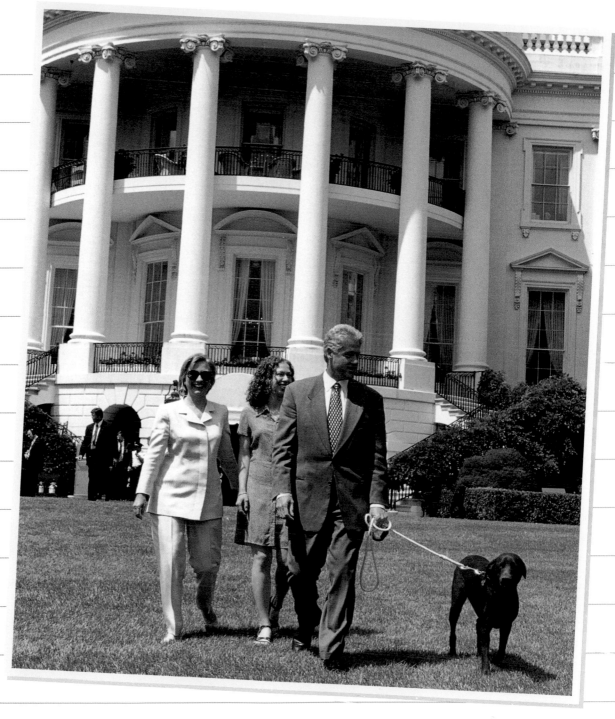

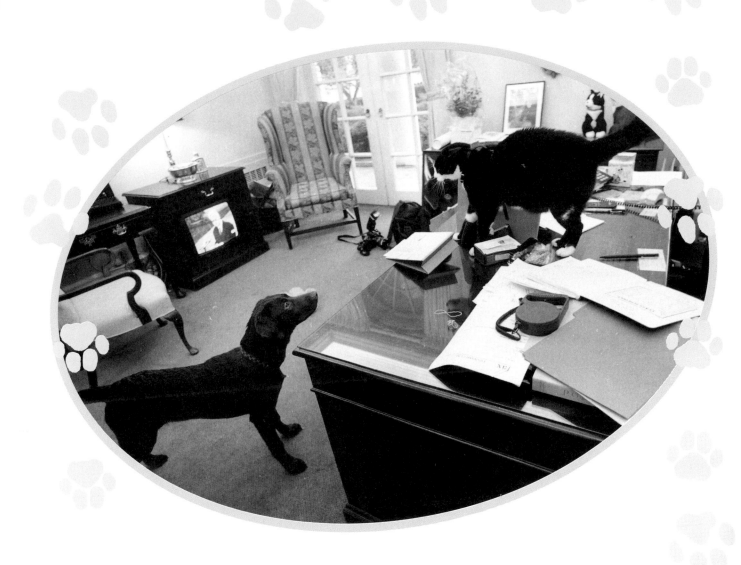

Dear Socks,

Are you happy in the white house? Does Buddy ever bother you? Are you happy now that Buddy lives with you or were you happier when he was not there? Do you liked to play with Buddy? I like to play with cats.

From,Sally

Dear Buddy (dog)

 Hi, how are things going? Do you like sox (cat)? I wish I had a dog! Do you help the president make new laws and goverment decisions? I wonder if you sleep in a dog house? Oh and can you send a picture of you and sox? Will you? Please do! One last thing do you ride in a helicopter? I guess not!

 Sincerly

Emily Forden

10 years old

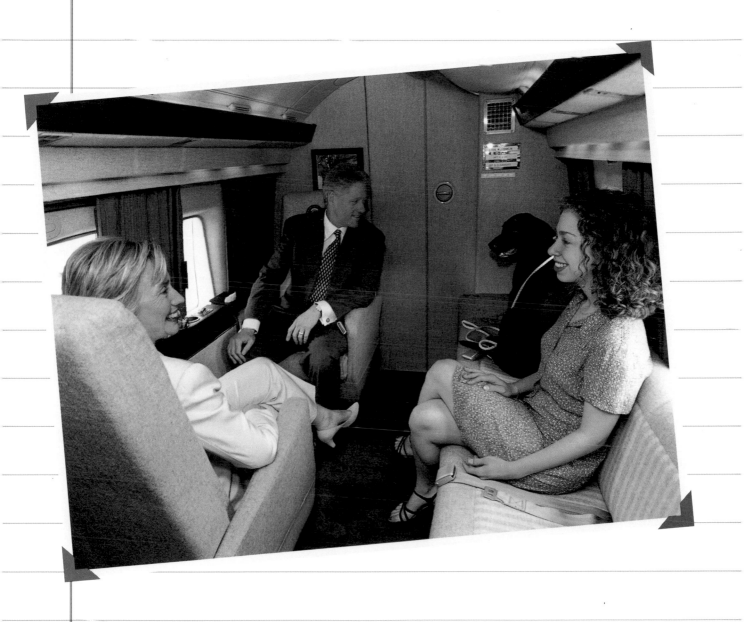

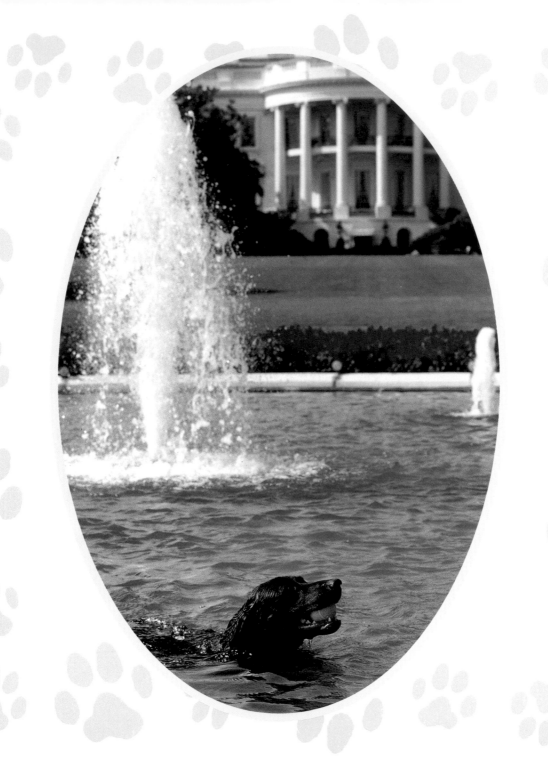

Dear Socks and Buddy,

 My name is Susanna. I am 7 years old. I live with my dog Zoë. She is a springer spaniel and is 14 in dog years. She loves to chase squirrels and chipmunks.
 What do you like to do for fun?

 Love,
 Susanna

P.S. I am writing this for Zoë because she is taking a nap.

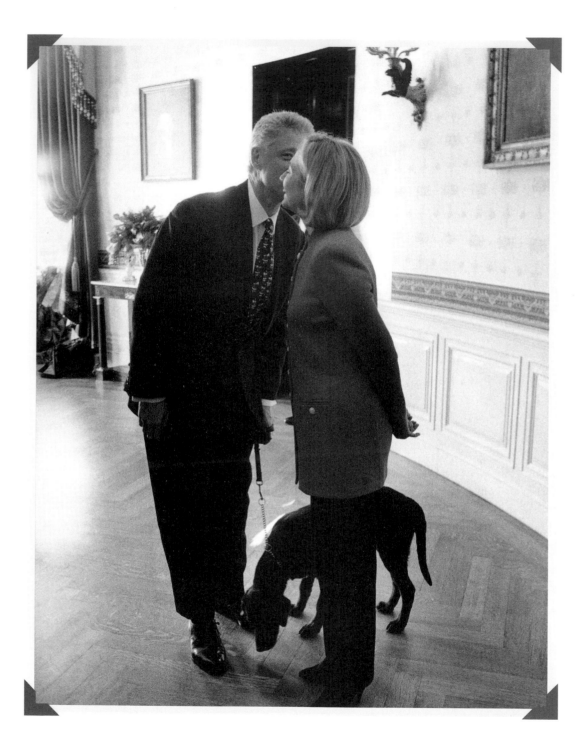

Dear Socks,
 My aunt has a dog named Princess
She is nice and sweet evreyone loved her.
but my aunt bought a new dog named
Chester. And he's small and fiesty. He
wrekes things to. Now no one loves
Princess I bet shes **JELLUS** and Chester
gets all the atention. I think it's
the same case with you and Buddy.
I got to admit he's pretty cute.
My parents won't Letme get a puppy!

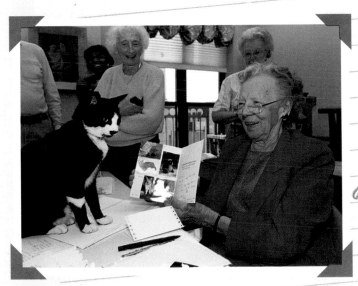

Your most very
unknown friend,
Jillian McGaffigan

Jillian McGaffigan

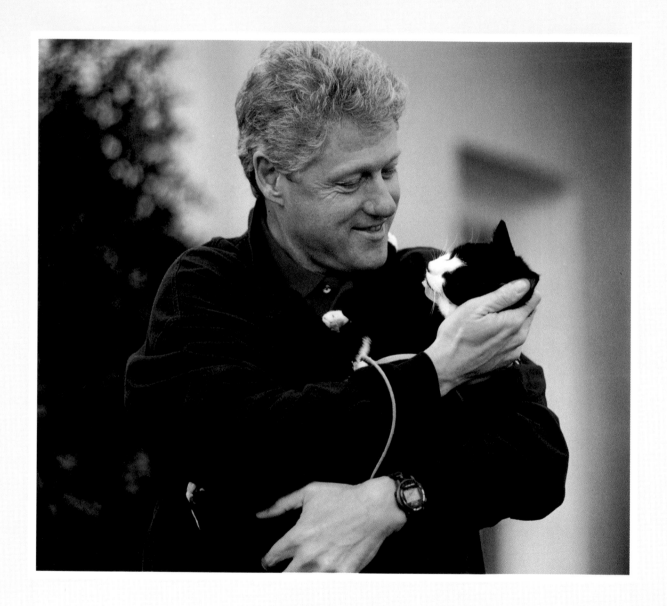

Dear Socks,

Hi! My name is Erik Waywood. I am in the third grade. I live in Hebron, Indiana. What is it like in White House? Is the red room relly haunted? We learned a lot about the Whit House. Does Buddy like to chase you? How is the president? Is there going to be a war in Iraq? Do you have secret service men because you never know when dogs might attack. Tell Mr. Clinton to keep up the good work!

P.S. Ask Mr. Clinton if I should run for president?

Your friend,

Erik

Dear Socks,

I hope you had a nice Christmas and a Happy New Year. I heard you got a new friend, a new dog friend. But I don't think you should slap him. By the way my name is Christopher Murphy. Oh yeah, do you like Buddy? Don't feel bad, because, they still love you, just because they went on a trip and you didn't. It doesn't mean they don't love you any more. I hope you have fun with Buddy.

Your friend,
Chris Murphy

P.S. Meow! Meow!

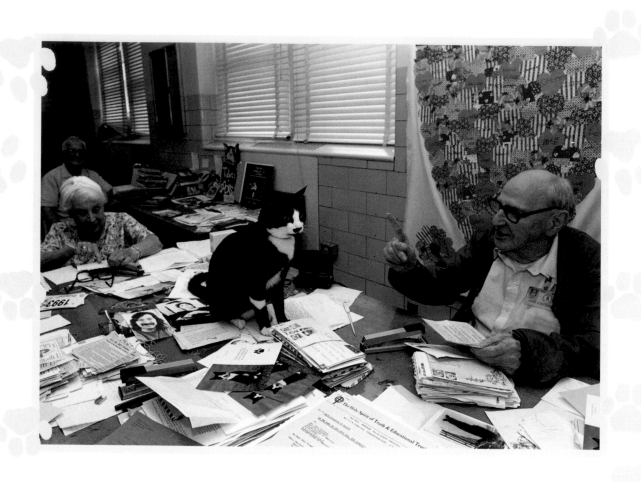

Dear Socks,

I think you're cute. I like you. I love you so much
I want to give you a big heart, as big as the
whole world. Please write back.

Love,

JEN

Dear Socks,

Meow, Meow! I heard you got into a fight with Buddy. Are you going to teach him some cat manners? I also heard you scratched Buddy across the face. Why didn't they take you on vacation with them? They took Buddy with them. Do you like it with Buddy around? I don't think you do. You used to have all the attention, but now Buddy has all the attention. Is Buddy a pest? I have a dog name Patti and she is a pest.

Your Friend,
Megan Margino

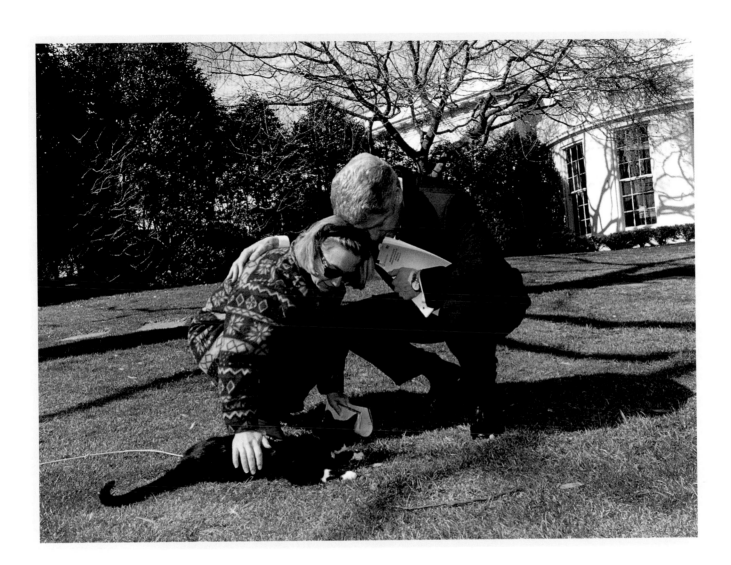

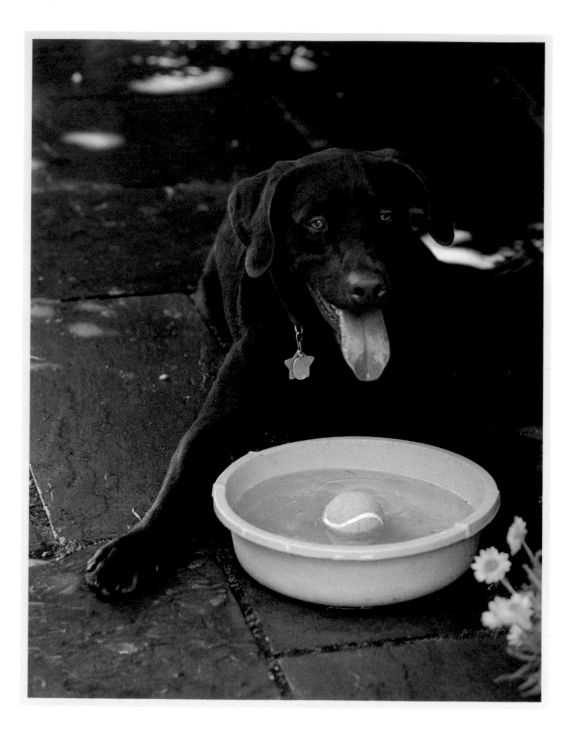

Socks and Buddy's Guide to Good Pet Care

I t is not just the First Pets who deserve first-rate care and attention. Socks and Buddy have helped me put together a list of suggestions that will help your animals stay safe, happy, and healthy.

· Pets need good housing

Like other cats and dogs, Socks and Buddy depend on the people who love them to keep them out of harm's way. The Humane Society of the United States recommends that all pets be treated as members of the family, living indoors and allowed to exercise and

play outside on a leash or in a secure
place. Cats and dogs that roam the
neighborhood by themselves are vul-
nerable to cars, injuries from other ani-
mals, poisonous substances, diseases,
theft, and abuse. We took this advice
when we moved into the White House
with Socks. Now, when he goes outside,
we put him on a long lead. Buddy
romps around inside the White House
fence.

• Animals need a dish of
their own

Although Socks and Buddy do not
have their own chef, Buddy would
gladly scarf down the special at the
White House Staff Mess every day
if we let him. Our veterinarian told
us that the best food to put in Socks'

and Buddy's dishes is high-quality cat or dog food that is well balanced and geared toward each animal's age. We make sure they can always get their paws on a bowl of fresh, clean water, too.

• Pets need plenty of time to play

Buddy is pretty insistent about playing catch with the President. Every animal's workout regimen depends on his breed, age, and health. (Note to Socks: Sleeping doesn't count as exercise!) The President and I take both Socks and Buddy for walks; it keeps them in better shape and helps them feel more content, especially when they come indoors. Walking is good for us, too.

• **Dogs and cats need a yearly check-up**

No matter where you get your dog or cat—whether he's a stray like Socks or a gift like Buddy—The Humane Society of the United States suggests that you take your new pet to the veterinarian's office for a check-up right away. Kittens and puppies need a series of vaccinations to protect them from disease, just like babies, and all animals should go to the vet annually

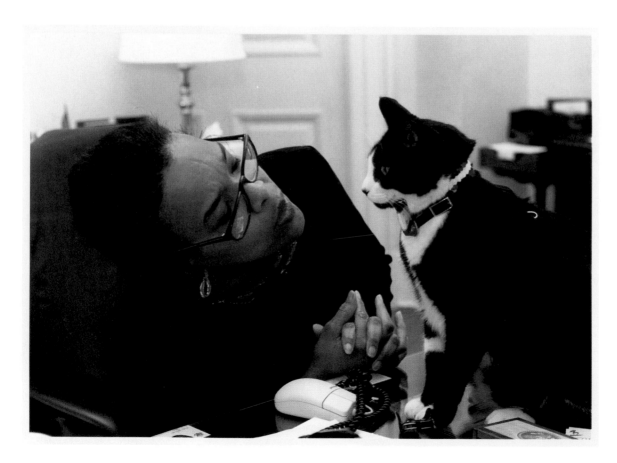

to be re-vaccinated and examined thoroughly.

• Kittens and puppies need to be neutered

When Bill and I made the decision to have Socks and Buddy neutered, we knew it was one thing we could do that would both benefit our pets' health and help them become even better animal citizens. Studies show that neutering can prevent a number of diseases in cats and dogs, including some types of cancer, and spayed or neutered pets tend to be more sociable companions. Neutering is good for the entire community. Shelters provide an invaluable service, giving lost or unwanted pets a safe temporary haven, but they cannot find a family for every animal. Each year, approximately five to six million dogs and cats have to be euthanized because they can't find a loving home.

• Pets need lots of love

Dogs and cats need companionship to thrive. Each time I watch Buddy race down the hall to greet Bill or listen to Socks purr when I scratch his ears, I am reminded that the affection we give our pets is rewarded many times over by the joy they bring us.

Dear Buddy,

I go to Grace Community Christian School. My teachers name is Mrs Killingsworth. I'm eight years old. I have 5 people who live in my family. I have seven best friends.

Are you a boy or girl? (Circle) Do you like being the presidents dog? Who takes care of you?

Love,

Audrey

P.S. Will you give me a paw-print and a picture of you and your family? And answer the questions.

Dear Socks & Buddy Clinton,

 Hi. My name is Mallory L. Nierman. I have two black labs at home. Colt who is one year and a half old, and Rem. Short for Remington about two years old. I love both of them very much.

 Guess what? Did I tell you that dogs and cats are my two out of three favorite animals? Well, they are. Horses are my other favorite animal. Buddy? I heard you are a new member of the family. How do you like it? Pretty big house hu. What kind of dog are you? I think you are cute. You are probably thinking how

would you know? You have never seen me before. Well, I ♥ all dogs. That answers you question.

And Socks? What kind of cat are you? Do you and Buddy get along together? Maybe. But let me tell you something. I used to have a cat, and Colt and her did not get along together. We do not have her any more because mom said it was too much for us. So, we gave her away. I miss her, but I know it was right.

Hope to hear from you two soon.

Yours truly,

Mallory Nierman

Dear Socks,

Do you like that dog just a little bit? If you get in to a fight I hope no one gets hurt. If I were you I'd stay away from the dog. At some point I hope you get along with Buddy. Are you a boy or a girl?

Your friend
Richard Jacobson

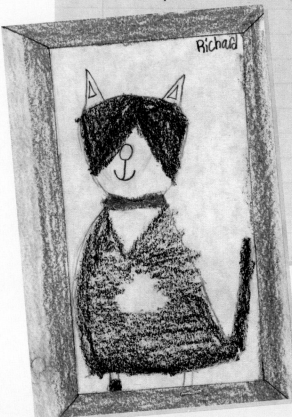

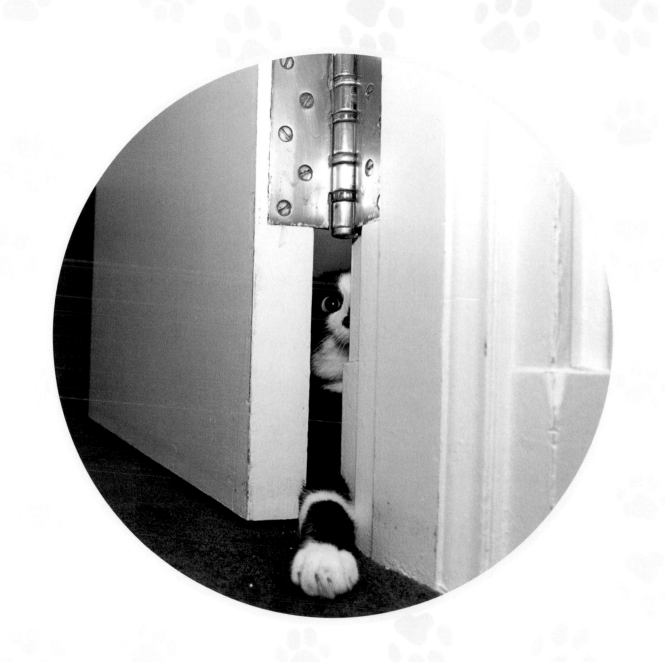

Dear Socks,

Does the dog chase you? Is it neat to be the president's cat? My dad won't let me get a cat. I wish I could borrow you for 1 day. If I could borrow you for 1 day I would play with you all day.

Sincerly,

Eric Czech

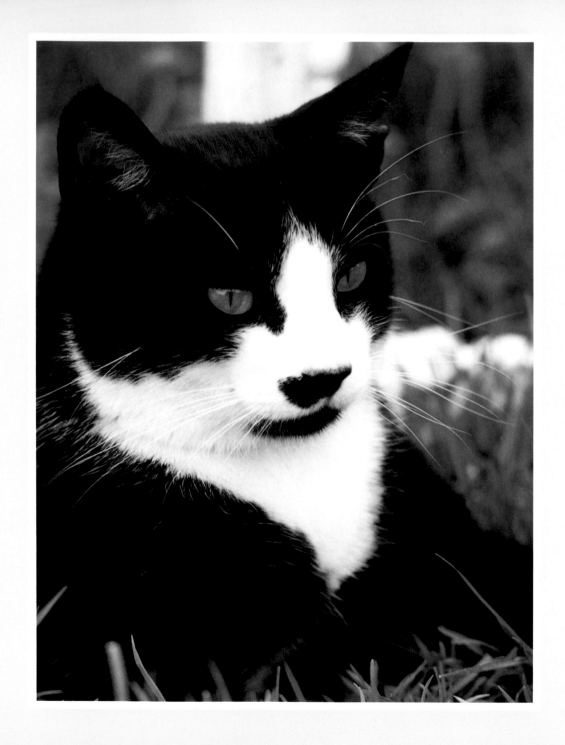

Dear Socks,

 I really love cats! They are my favorite animal in the world. But my daddy doesn't like cats. He won't let me have one. I would really like to have a picture of you since I can't have my own cat.

 Mandy

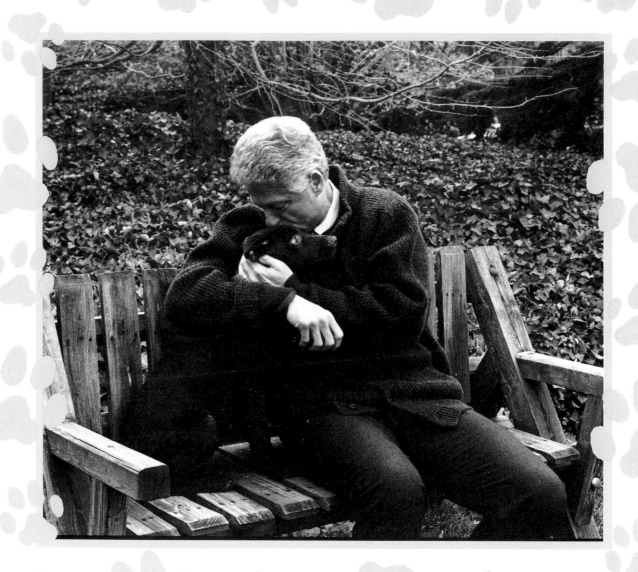

Dear Socks and Buddy,

Are you two geting along too geter? How are you Socks and Buddy? Is Bill Clinton nice to you. Socks and Buddy won't you come to school to see us? Please Socks and Buddy. It would be good to see you two. Take care of Bill Clinton and Ms. Clinton. Send me a post card please.

Your Frend,

Aaron

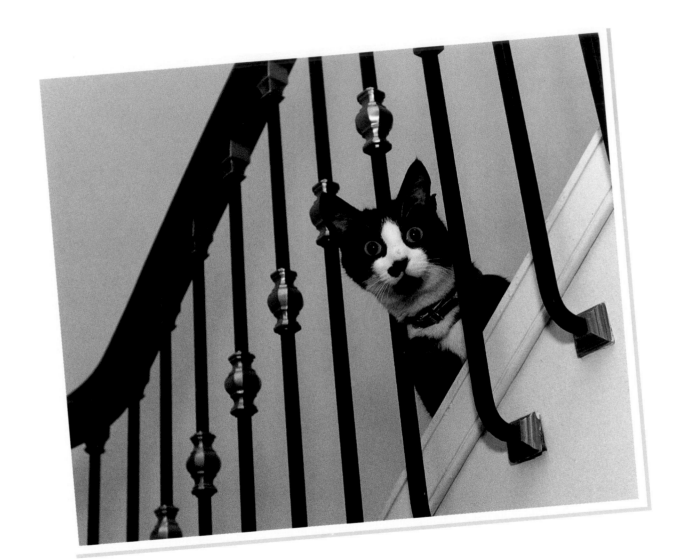

Dear Socks,

Does Buddy bug you? Or do you bug buddy? Did you like being the only pet in the white house or would you rather be with Buddy.

I think Socks is a better name then fluffy or whiskers. I have two turtles named Ike and Sophie. I think you are the cutest cat in the world. May I have a picture of you. I'll write to you agian bye.

your friend
Hope McCarthy

P.S. Do you like living in the white house?

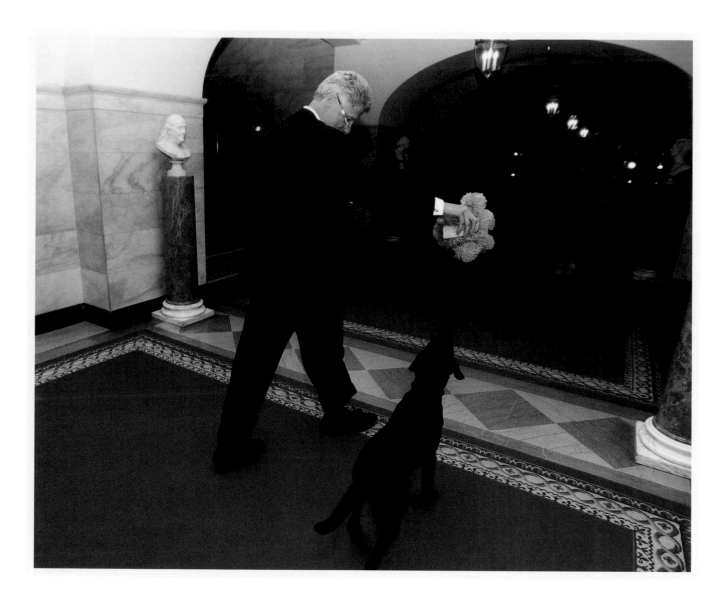

Dear Soxs + Buddy,

I love animals especially cats + Dogs. I think you are cute, sweet, well behaved + loved. I know you live in Washington D.C. I hope soon can you come to Georgia. It would be nice If the President can bring you. I would love to meet him. Soxs, I hope you don't like mice cause I have a gerbil. Buddy, I hope you don't chase Soxs.

Love,

Abbey Agati Age: 8

Dear Socks,

Do you like having Buddy around? Do you both get in fights? I hope not becuse it would be a mad house! I want a cat but we are too busy I have one. Thats why I go to child care. Could you send me a picture of you. You are probably very cute. I want to be you. You probably have a big chair that said "Socks" and watches cat t.v.

From
your
Friend,
Emily Coleman

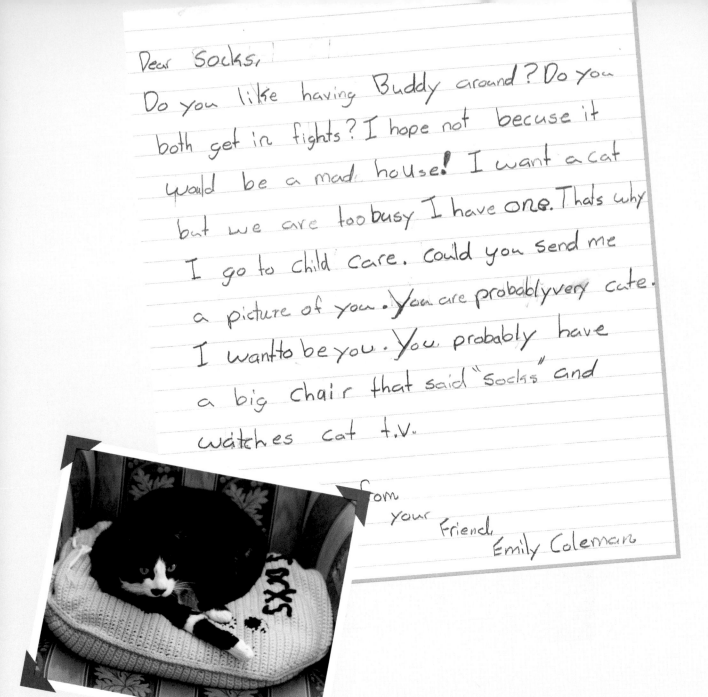

Socks taking a Cat Nap

Dear Socks,

How old are you Socks? What is the best place to explore in the White House? Were do you sleep? I am eight years old. I go to Holy Trinity school. I love corn. My name is Patrick Collins. Do you like cat food? What is the biggest room in the White House?

Sincerely,
Patrick Collins

Dear Socks,
 My name is Harveen
Gill. I am 8 years old. How are you
doing? I am in Mrs. House's class.
In case you don't know, please don't
cat-scan this page. I have always
wanted to write to you. Since
Buddy came are you feeling left
out? Does the F.B.I. or the
air force keep a really, I mean,
really good eye on you? I think
you are one of the cutest cat
in all of the 50 states. That
fur is in style these days.
Do you get to hear Clinton's
secrets?

P.S. Please write back.

 Sincerely

 Harveen Gill

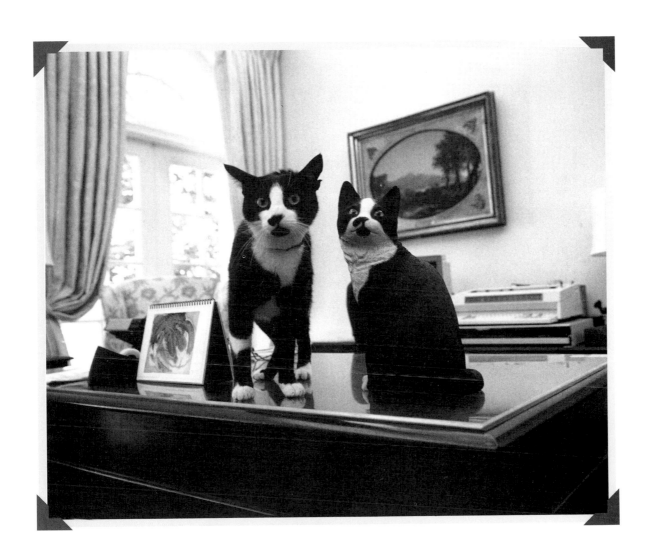

Socks in front of the
American flag

Stephen Fleming

A Note on Saving America's Parks and Treasures

Dear Socks, Dear Buddy wouldn't exist without the children and families who wrote to our pets. I would like this book to encourage the American people to expand their interests beyond our animals and the White House to the many other historic and cultural riches our country has to offer. All of my proceeds from this book will be assigned to the National Park Foundation, the nonprofit partner of the national parks, where so many of our country's landmarks are located.

I wanted to find an organization that would have meaning for all the children who gave so much of themselves through their letters. I also wanted that place to have a strong connection to the White House, where Socks and Buddy live. Sometimes, when I look out of my window, I can see a groundskeeper throwing a ball to Buddy or stopping to pet Socks. These men and women are part of the National Park Service, which does a wonderful job taking care of the White House grounds where our animals play. I can also see the Washington Monument and the Jefferson Memorial honoring two of our most distinguished American patriots (and tended by the Park Service as well). Living in the White House with Bill, Chelsea,

Socks, and Buddy has brought home to me the importance of protecting the heritage that embodies our nation's memory to inspire future generations.

As I go about the business of my day, I am constantly reminded of the families who made this house their home before us; each one has left something of themselves behind. The portraits and beautiful objects on display in the halls and rooms of the White House are convincing evidence that none of us owns our country's past, and we are all its caretakers. We have the responsibility of safeguarding the gifts we have received and passing them on to those who come after us. That is the idea behind the White House Millennium programs, and

especially our initiative to Save America's Treasures.

The President and I created the White House Millennium Council in 1997 to mark the approaching millennium in meaningful ways. We invited all Americans to "honor the past and imagine the future," and to join together to build a positive future for the nation. As we discussed our plans with historians, artists and writers, state and local officials, and federal agencies, we became more and more aware of the need for Americans to understand our common heritage and to take our shared values and history with us into the next millennium. One program we launched to help us imagine a promising future is Millennium Evenings at the White House, a series of lectures and cultural showcases that highlight creativity and inventiveness through our ideas, art, and scientific discoveries. Held in the East Room of the White House, these events are also broadcast and cybercast so that all Americans can participate and even send in questions to the guest speakers via e-mail. The Millennium Council also has plans under way to recognize communities and to designate scenic and heritage trails for their distinctive contributions to our nation's past, present, and future.

To stimulate preservation activities around the country, the President created the Millennium Fund to Save America's Treasures—a public-private

partnership to preserve the nation's documents, artifacts, monuments, and historic sites in danger of deterioration.

To promote the private partnership efforts, the National Trust for Historic Preservation established a new Millennium Committee to Save America's Treasures. The National Trust for Historic Preservation, a nonprofit organization that provides leadership and education and advocates to save America's diverse historic places and revitalize our communities, will work closely with two other nonprofit organizations. One is Heritage Preservation, Inc., a leading advocate for the preservation of America's historic legacy, including works of art, books,

documents, films, and videos. Another organization, the National Park Foundation, is also an important part of the effort to Save America's Treasures. I am committed to passing our history on to our children, grandchildren, and all the children to come. That is why I agreed to become the honorary chair of the Millennium Committee to Save America's Treasures.

In July 1998, I took a tour to help raise awareness of threatened sites and artifacts in four states that began with the Star-Spangled Banner at the Smithsonian Institution's National Museum of American History in Washington. Each place we stopped told a different story, from the importance of our outdoor sculptures at the Francis

Scott Key Monument in Baltimore to the oldest state historic site in the country at George Washington's Revolutionary War Headquarters in Newburgh, New York. As people learned about the importance of these sites and relics and their imperiled condition, they stepped forward to give donations large and small.

Our hope is to help people recognize that every town has a monument or document worth preserving that tells of the past and points toward the future. Saving America's treasures is not just the province of people who call themselves preservationists. It is an opportunity for every American to contribute. It may be pennies collected from a kindergarten class, a multimil-

lion-dollar contribution from a large corporation, or the gift of time given by those willing to roll up their sleeves and help do the hard work of scraping and painting.

Usually, when we talk about national parks, what comes to mind are august wilderness areas such as Yellowstone and Yosemite. But of the 376 sites in the park system, nearly 60 percent are sites with a historical mission. One of the stops on my tour, Thomas Edison's Invention Factory in West Orange, New Jersey, the birthplace of the first motion picture camera and the phonograph, is a National Park Foundation Save America's Treasures project. *Life* magazine named Edison the person in this mil-

lennium who had the greatest influence on how we live today. It will cost millions of dollars to restore Edison's laboratories and protect his archives.

Another National Park Foundation project is the *Brown* v. *Board of Education* National Historic Site in Topeka, Kansas, which commemorates the Supreme Court decision ending school segregation throughout the nation. The Monroe school, a hallmark of the civil rights movement, is in disrepair and unsafe for visitors. Mesa Verde National Park in Colorado is the ancient home of people known as the Anasazi, who lived there from about A.D. 1200 to A.D. 1300. It was named one of America's Eleven Most Endangered Places in 1998 by the National Trust for Historic Preservation. Of the six hundred cliff dwellings (the most important such pre-Columbian structures in the world) the National Park Service has the resources to provide regular maintenance for only forty to fifty. Many of the cliff dwellings suffer from collapsing walls, sagging roofs, and eroding mortar; some are in such poor condition that they could be lost within a few years unless steps are taken soon to protect them. The M'Clintock House in Seneca Falls, New York, where the famous "Declaration of Sentiments," a milestone of the women's rights movement, was penned 150 years ago is part of the Women's Rights National Historic Park and is badly in need of restoration.

There are other places that hold significant chapters of our past. Save America's Treasures is working to create opportunities for corporate partnerships and other private support to help fund the restoration of these landmarks as well—for example, Anderson Cottage, which provided a summer refuge for Abraham Lincoln (not only one of our greatest Presidents but also a big fan of cats) and his family from the swampy heat of the nearby Potomac River. This simple house is located on the grounds of the U.S. Soldiers' and Airmen's Home, where retired military men and women volunteer to answer the letters for Socks and Buddy. It was there that the sixteenth President wrote the final draft of the Emancipa-tion Proclamation in which he declared slaves in all states waging war against the Union to be "forever free." It is listed on the National Register of Historic Places, a program run by the National Park Service and each state's historic preservation office; renovations soon will begin on the building so that it can be opened to the public.

I have many pleasant memories of visiting national parks with Bill and Chelsea, and I hope these national treasures will always be available for children and families. In this era of great blessings, there is no reason to take our liberties for granted and no time to put off thinking about what we must do to make sure this country

remains strong into the future. The same goes for our national treasures. We cannot imagine our future without these riches and the stories they tell.

Preserving our national treasures is a never-ending job—much like taking care of a house. There's an ongoing list of projects, whether to stormproof the windows, replace the roof, or replant the garden. Just as it is up to homeowners to lovingly maintain their homes, it falls to each of us to protect these treasures for the next generation to learn from and enjoy. If you would like to help Save America's Treasures, you may call any of the following organizations for more information

about getting involved. These organizations also accept donations at the same addresses to benefit their treasures and national park initiatives.

Save America's Treasures
National Trust for Historic
 Preservation
1785 Massachusetts Avenue, N.W.
Washington, D.C. 20036
Internet address:
 www.national-trust.org

Heritage Preservation, Inc.
1730 K Street, N.W.
Suite 566
Washington, D.C. 20006
Internet address:
 www.heritagepreservation.org

National Park Foundation

17th Street, N.W.

Suite 1102

Washington, D.C. 20036

Internet address:

www.nationalparks.org

The National Park Service's official index, with information about each park, is titled *The National Parks: Index 1997–1999.* It is available for $6.50 (ask for stock number 024-005-01182-0) by credit card from the Government Printing Office at (202) 512-1800, or through the Internet, at www.nps.gov.

Finally, below is the White House Millennium Council logo. In the future, you will see this logo associated with millennium projects such as Save America's Treasures. When you see this logo, you will know that the project is part of the White House initiative to commemorate the millennium by encouraging all Americans to "Honor the Past—Imagine the Future."

THE WHITE HOUSE
MILLENNIUM COUNCIL

Resources

Here is a list of books I found particularly helpful in case you'd like to read more about helping your children write, pet care, or pets in the White House.

Calkins, Lucy McCormick. *The Art of Teaching Writing*. Portsmouth, N.H.: Heinemann, 1994.

Cullinan, Bernice, and Brod Bagert. *Helping Your Child Learn to Read*. Washington, D.C.: U.S. Department of Education, supported by a grant from the General Electric Fund, 1997. Available free from the Consumer Information Center, Pueblo, CO 81009.

Kelly, Niall. *Presidential Pets*. New York: Abbeville, 1992.

Lane, Marion S. *The Humane Society of the United States Complete Guide to Dog Care*. Boston: Little, Brown, 1998.

Learning Partners. Washington, D.C.: U.S. Department of Education, 1997. Available for 50¢ from the Consumer Information Center, Dept. 308E, Pueblo, CO 81009.

Mammato, Bobbie. *Pet First Aid*. St. Louis: Mosby, 1997.

Rowan, Roy, and Brooke Janis. *First Dogs: American Presidents and Their Best Friends*. Chapel Hill, N.C.: Algonquin, 1997.

Siegal, Mordecai, ed. *The Cornell Book of Cats*. New York: Villard, 1989.

Truman, Margaret. *White House Pets*. New York: David McKay, 1969.

Credits

Photographs:

Pages 2, 3, 6, 7, 8, 9, 13, 17, 19, 20, 23, 24, 27, 28–29, 30, 35, 36, 39, 40, 41, 46, 47, 49, 60, 62, 63, 69, 70, 71, 74, 76, 82, 85, 86, 89, 90, 92, 94, 97, 99, 100, 101, 108, 113, 115, 120, 123, 125, 129, 130, 133, 136, 137, 141, 142, 146, 148, 152, 154, 155, 156, 159, 160, 161, 163, 164, 165, 168, 171, 175, 177, 180, 182, 184, 186, 191, 193: Barbara Kinney/White House Photo Office

Pages 12, 51, 57, 58: UPI/Corbis-Bettmann

Page 42: Donald R. Broyles/from the private collection of President and Mrs. Clinton

Page 43: Skipworth/from the private collection of President and Mrs. Clinton

Page 44: Agence France-Presse

Pages 50, 52, 56: Reproduced from the collection of the Library of Congress

Pages 53, 55: Official White House photographs

Page 54: Used by permission of the John F. Kennedy Library

Pages 66–67, 145: Sharon Farmer/White House Photo Office

Pages 112, 116, 144: Bob McNeeley/White House Photo Office

Page 132: Callie Shell/White House Photo Office

Pages 147, 151, 166–67, 178: Ralph Alswang/White House Photo Office

Illustrations:

Illustration on page 15 by Katy Key

Illustration on page 32 by Rachel Conkey

Illustration on page 119 by Zhiela Ashtianipour

Illustration on page 188 by Mary Ann Nov

Illustration on page 192 by Stephen Fleming